FINE LINE TATTOO DESIGNS

To properly care for a tattoo, it is essential to follow a series of steps that will help ensure proper healing and maintain the quality of the design. Below are the most important recommendations:

Initial Care

1. <u>**Cleaning**</u>: Wash the tattoo with warm or cold water and neutral, unscented soap, at least twice a day. It is crucial to do this with clean hands to avoid infection.

2. <u>**Drying**</u>: After washing, pat the skin dry with a single-use towel or kitchen paper. Avoid rubbing the area.

3. <u>**Hydration**</u>: Apply a moisturizer recommended by the tattoo artist, making sure it is completely absorbed before applying a new layer.

4. <u>**Bandage**</u>: Maintain the initial bandage (such as plastic wrap or Dermalize) for a minimum of 2 hours and a maximum of 24 hours, according to the tattoo artist's instructions.

PRECAUTIONS TO AVOID

1. **DO NOT SCRATCH**: AVOID SCRATCHING OR REMOVING SCABS THAT FORM, AS THIS CAN AFFECT THE QUALITY OF THE TATTOO AND CAUSE INFECTIONS.

2. **AVOID SUBMERGING**: DO NOT SUBMERGE THE TATTOO IN WATER (SWIMMING POOLS, HOT TUBS, ETC.) FOR AT LEAST TWO WEEKS TO PREVENT INFECTION.

3. **SUN PROTECTION**: KEEP THE TATTOO AWAY FROM THE SUN AND AVOID TANNING BEDS. ONCE HEALED, USE SUNSCREEN TO PRESERVE THE COLORS.

4. **APPROPRIATE CLOTHING**: WEAR LOOSE, SOFT CLOTHING TO AVOID FRICTION ON THE TATTOOED AREA DURING THE FIRST WEEKS.

SIGNS OF INFECTION

IT IS NORMAL TO EXPERIENCE SLIGHT REDNESS, ITCHING AND PAIN DURING THE FIRST FEW DAYS. HOWEVER, IF YOU NOTICE:

- SEVERE PAIN
- FEVER OR GENERAL MALAISE
- SPREADING REDNESS
- SUPPURATION OF PUS

YOU MUST SEE A DOCTOR IMMEDIATELY.

BY FOLLOWING THESE GUIDELINES, YOU CAN ENSURE PROPER HEALING AND ENJOY YOUR TATTOO IN ITS BEST CONDITION.

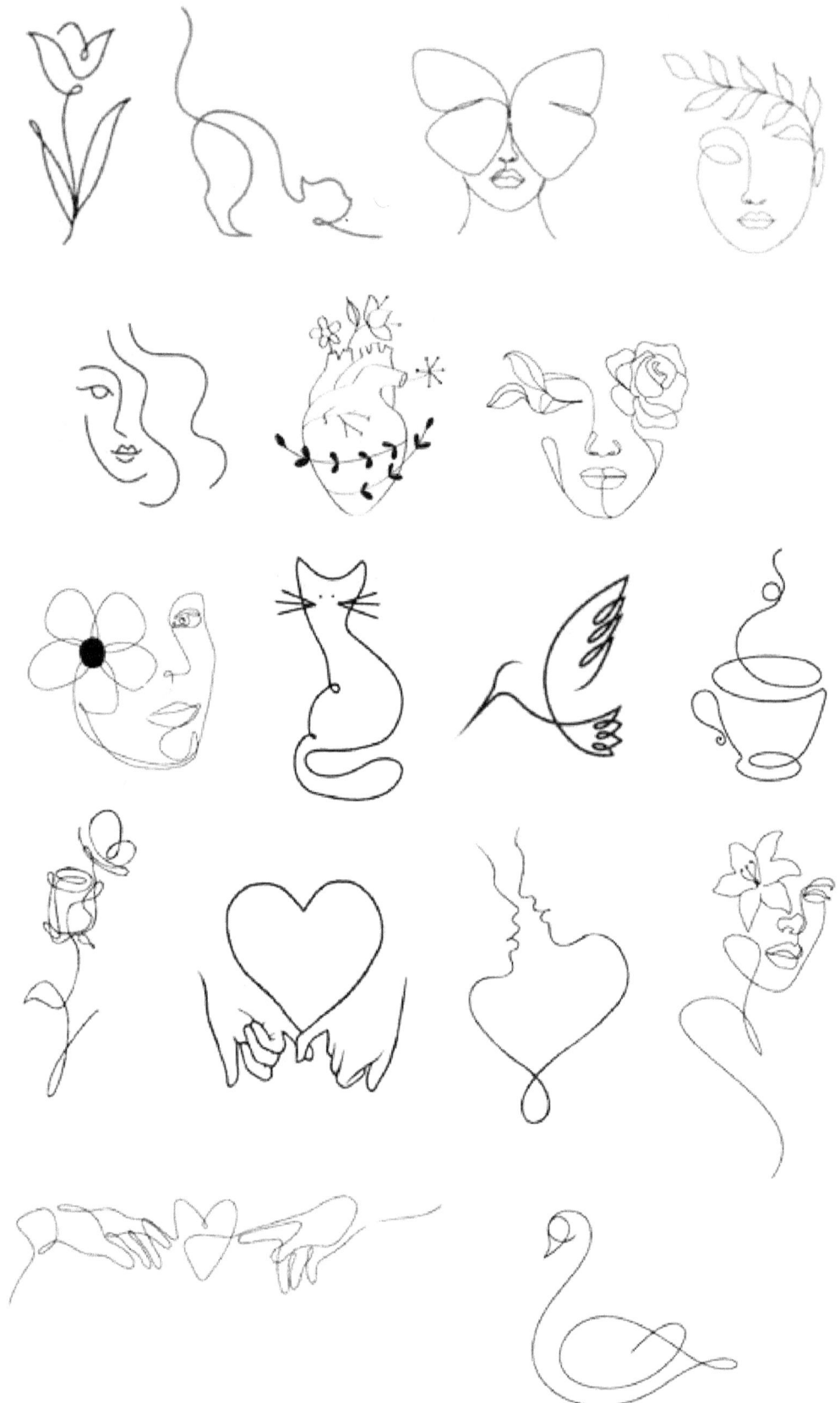

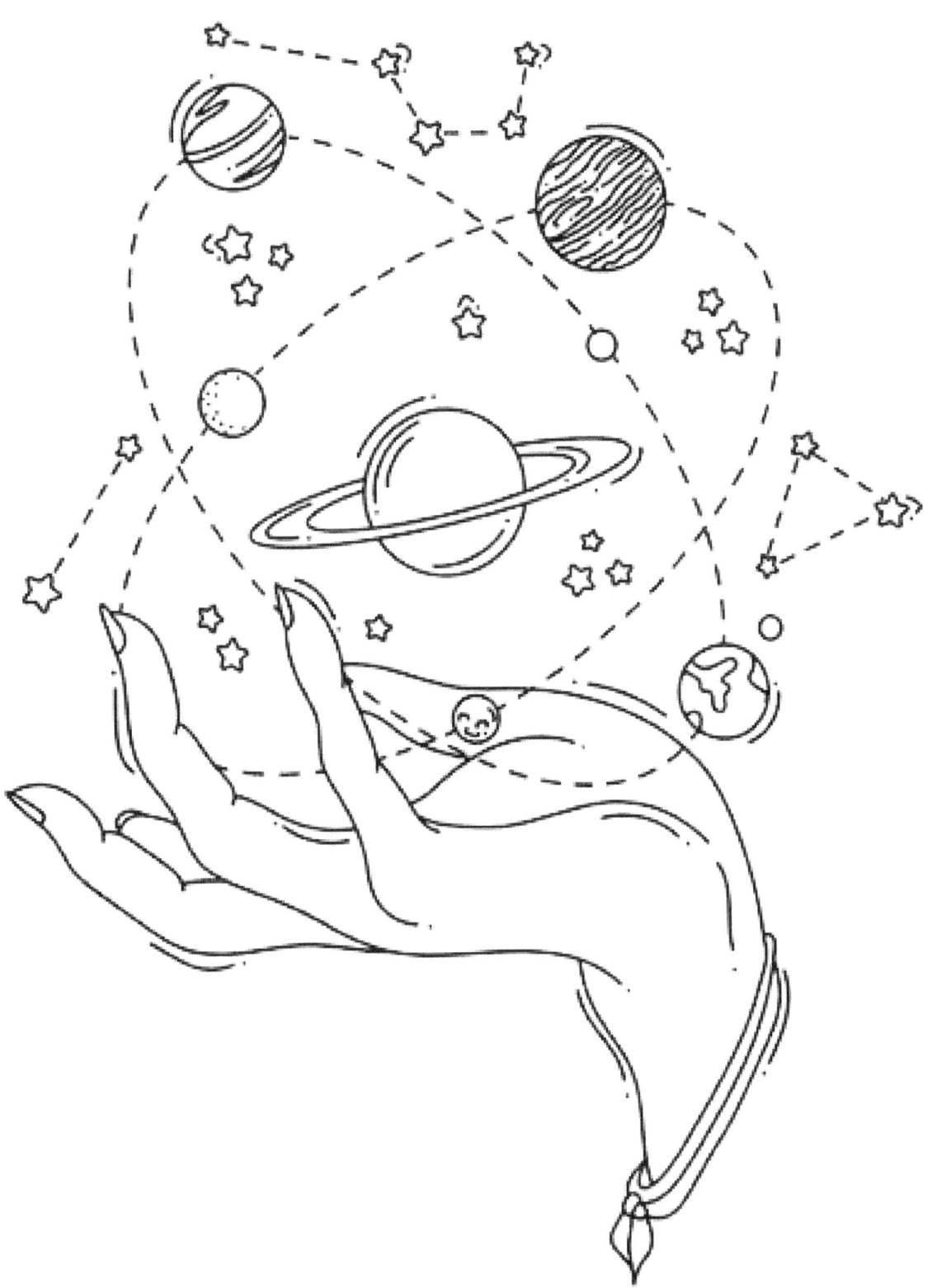

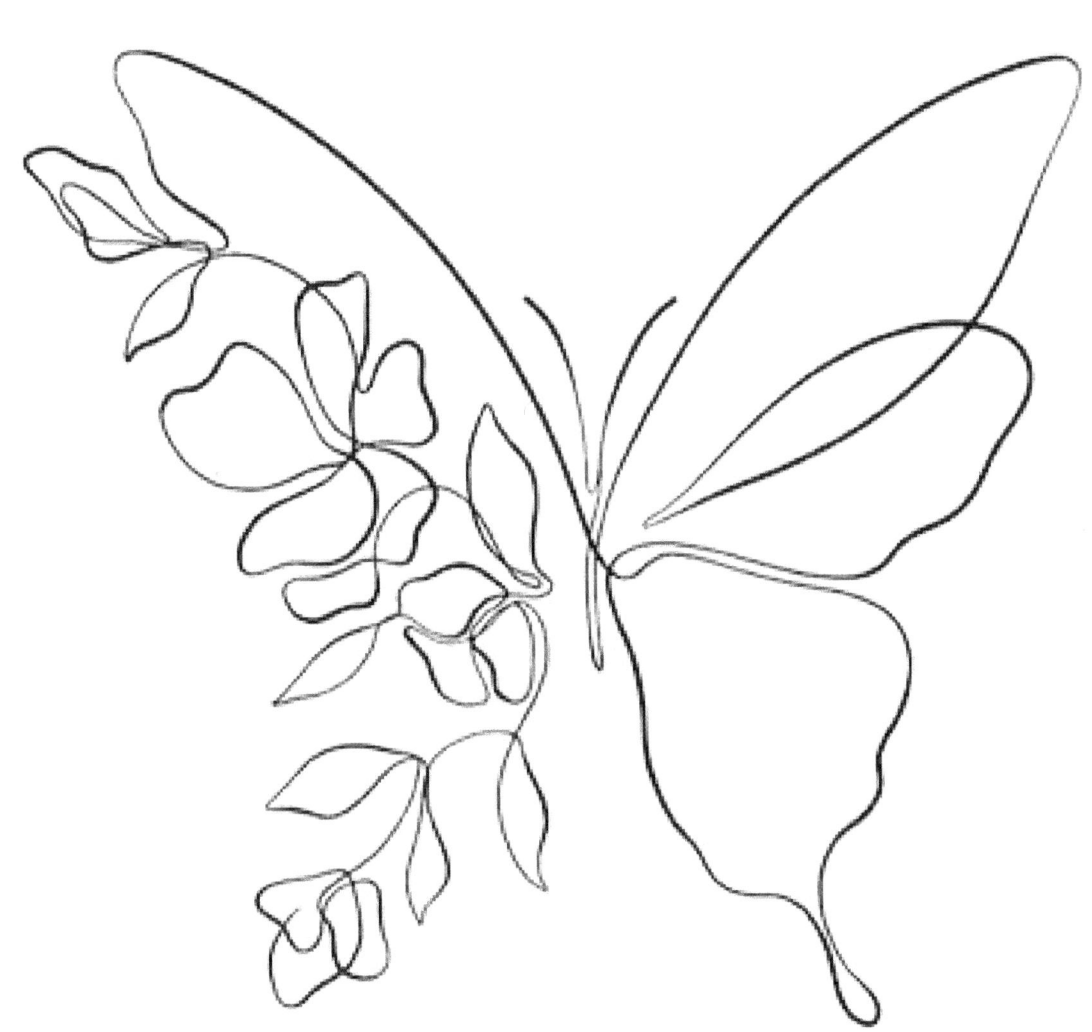

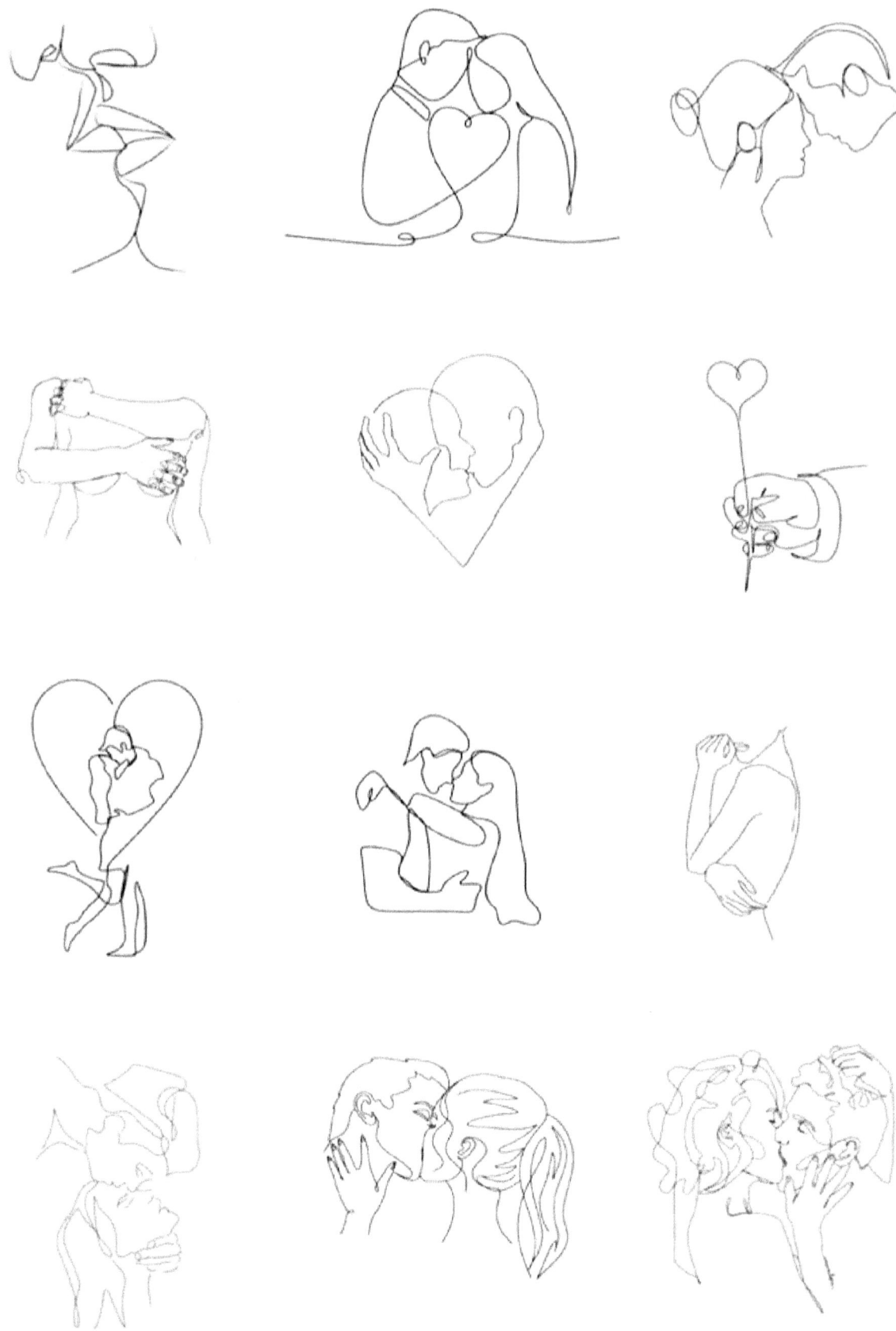

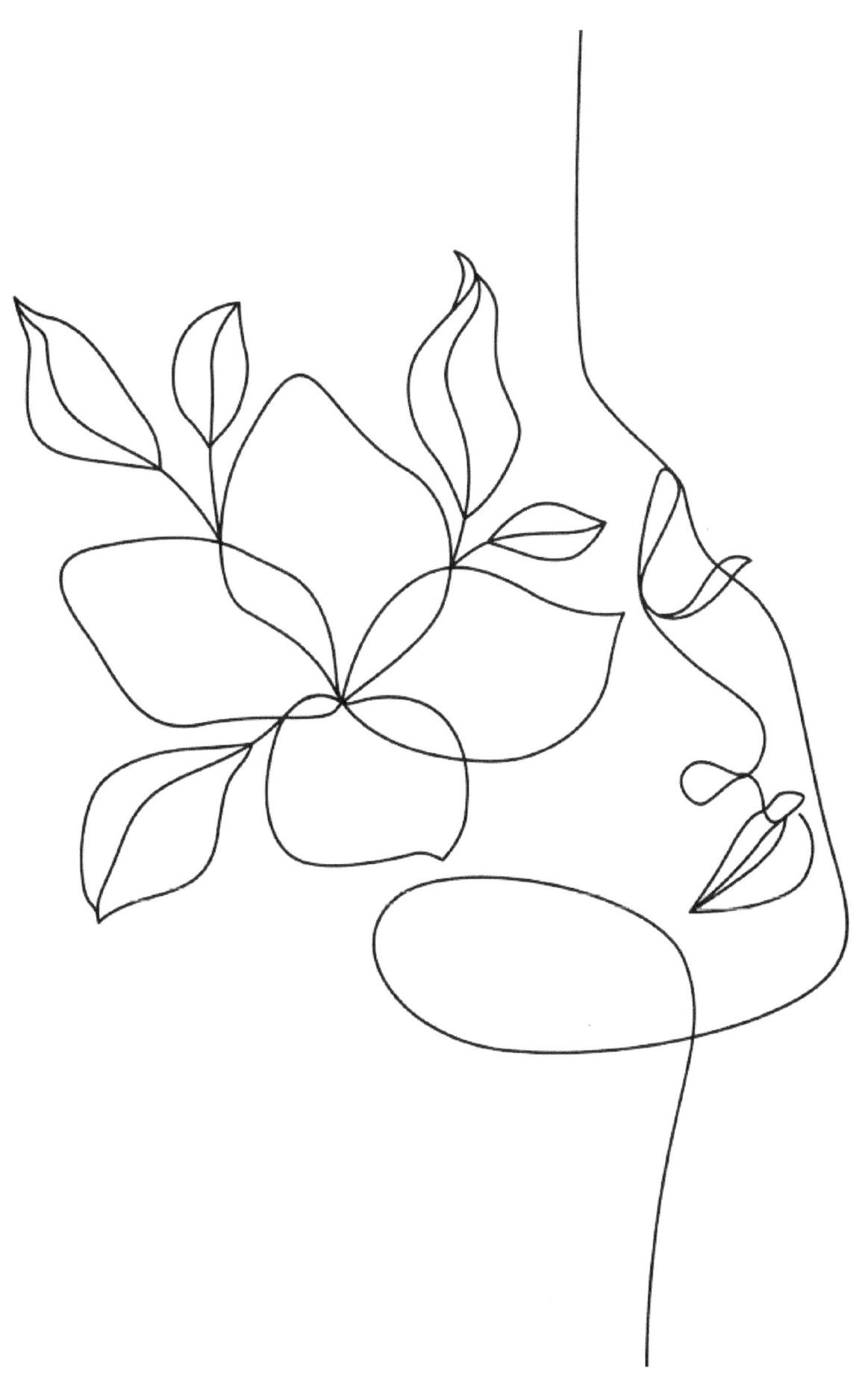

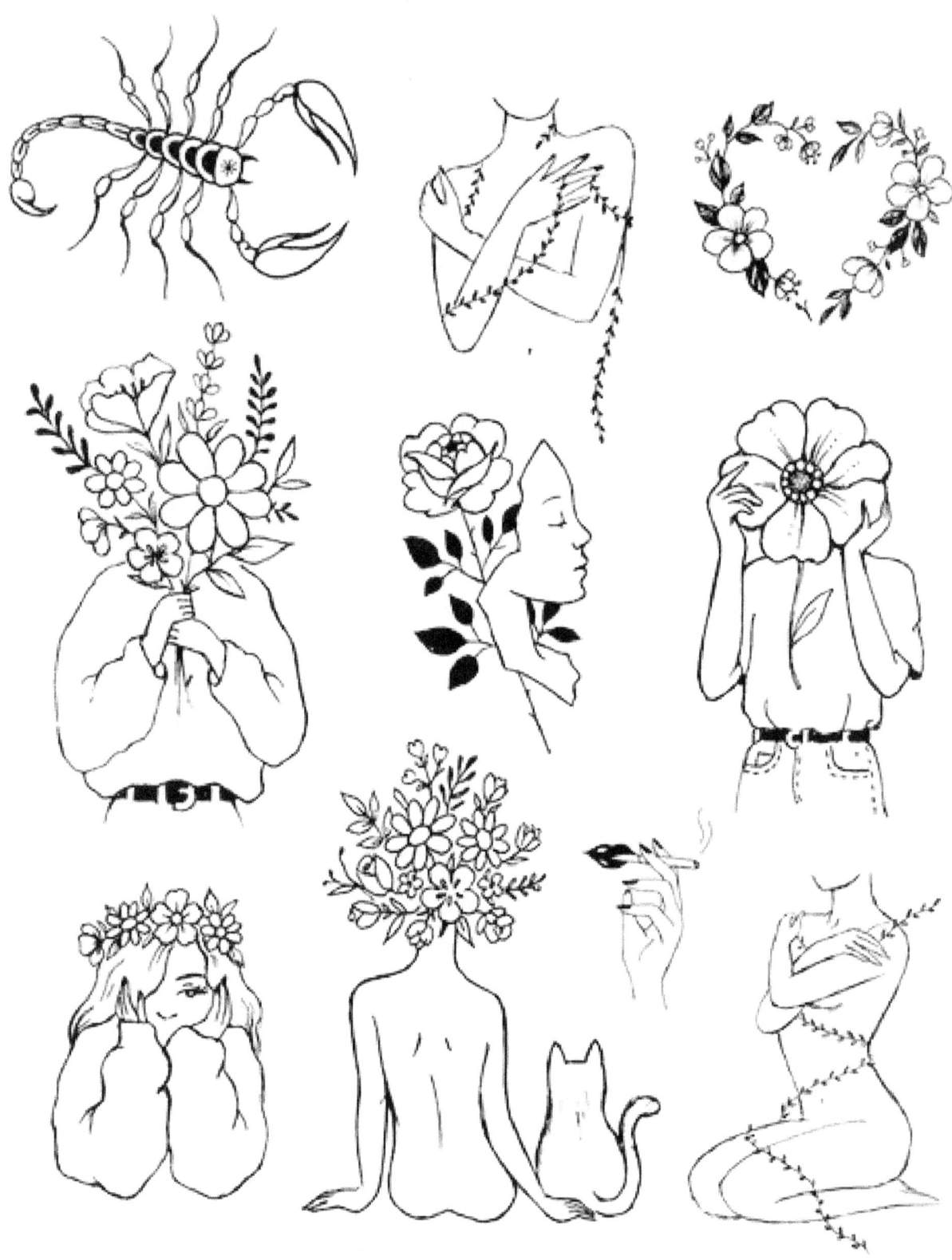

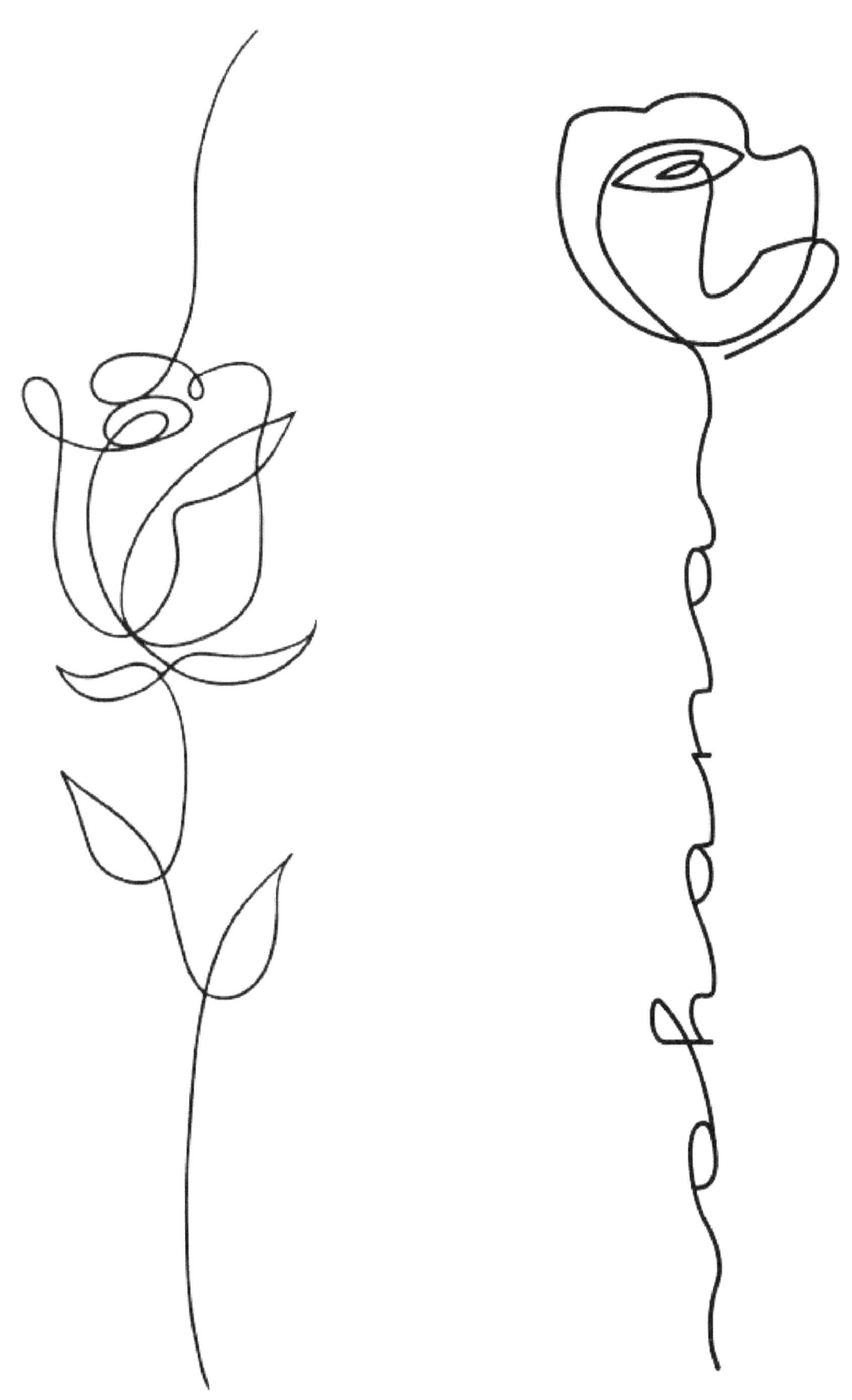

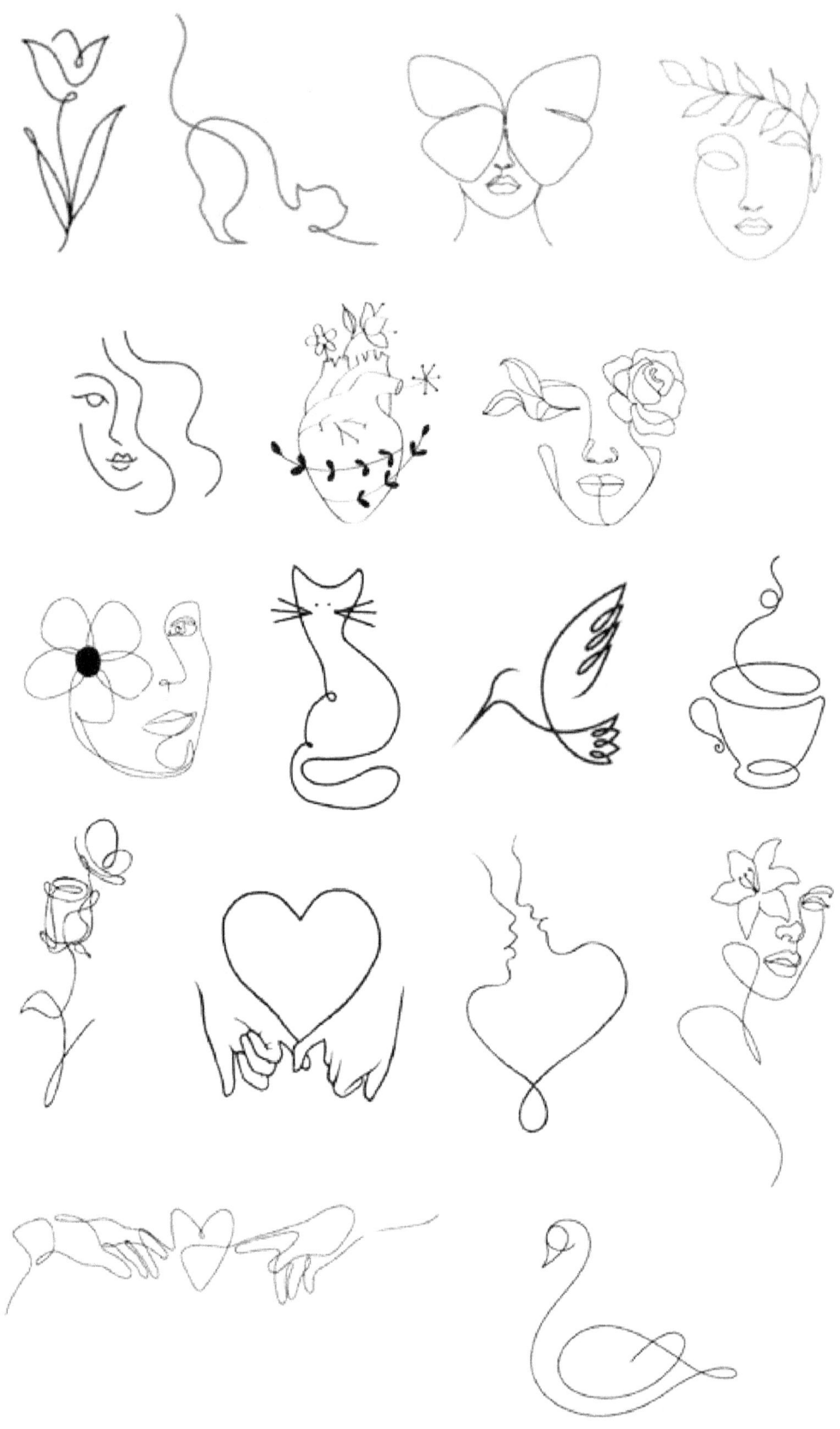

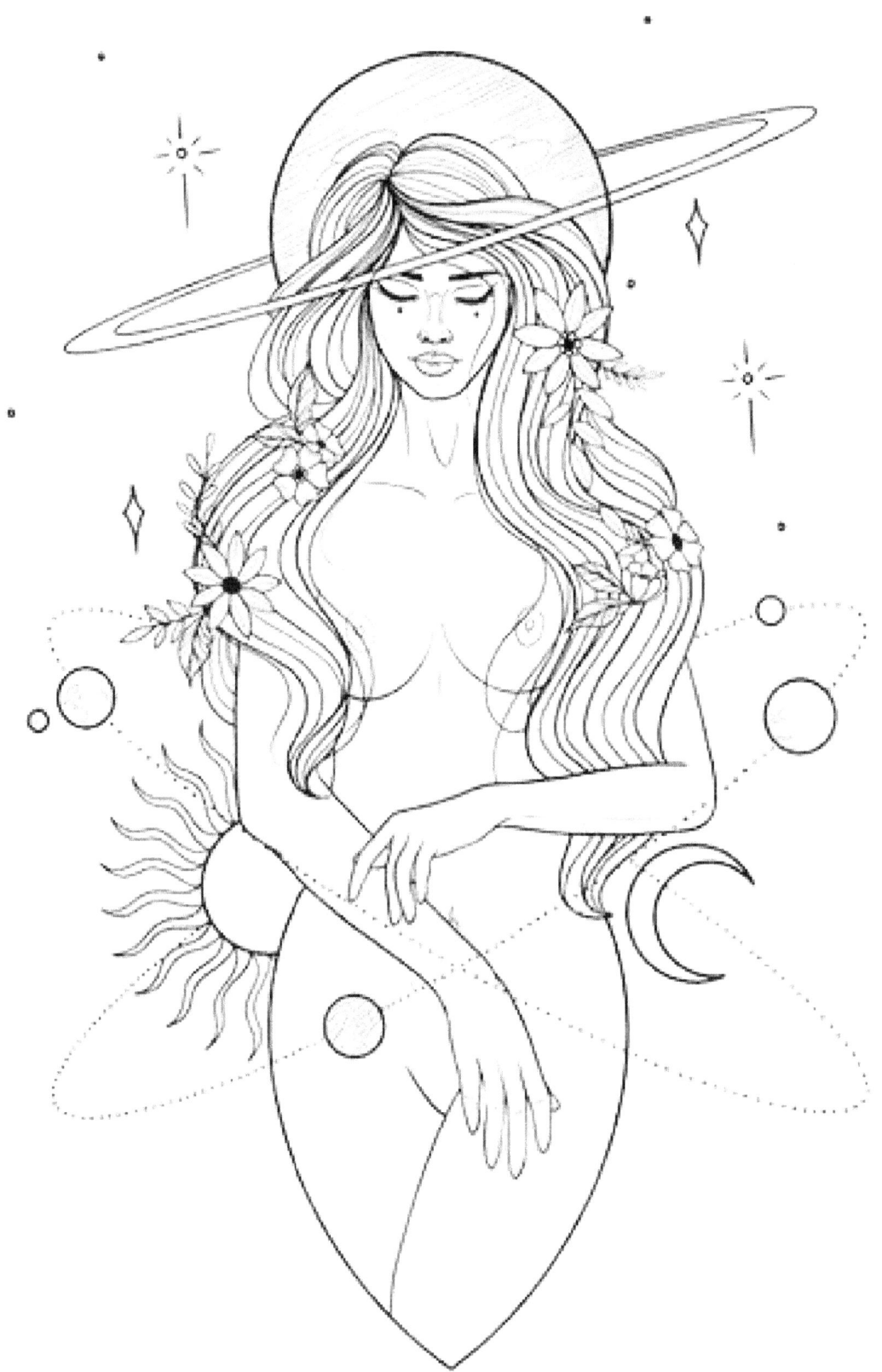

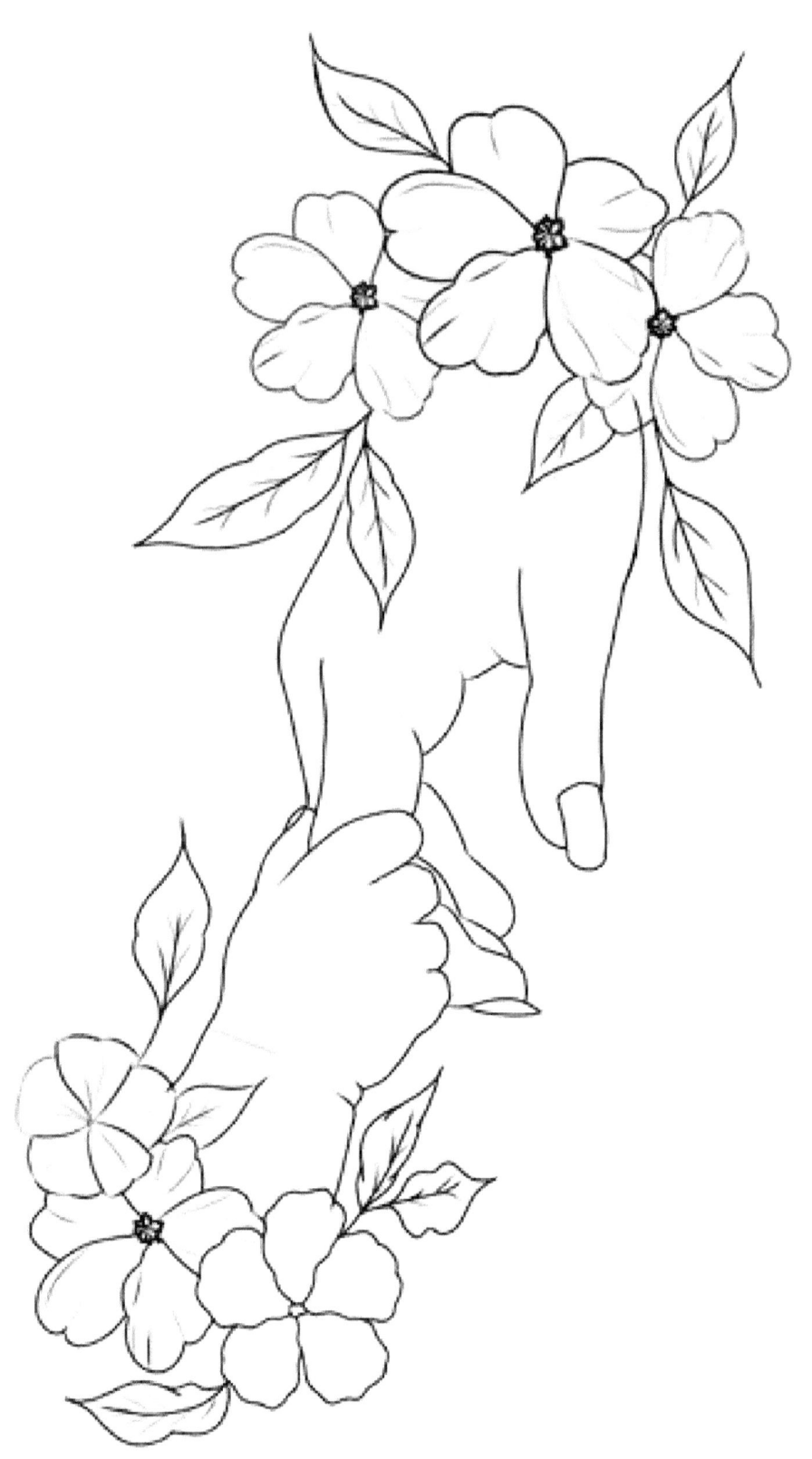

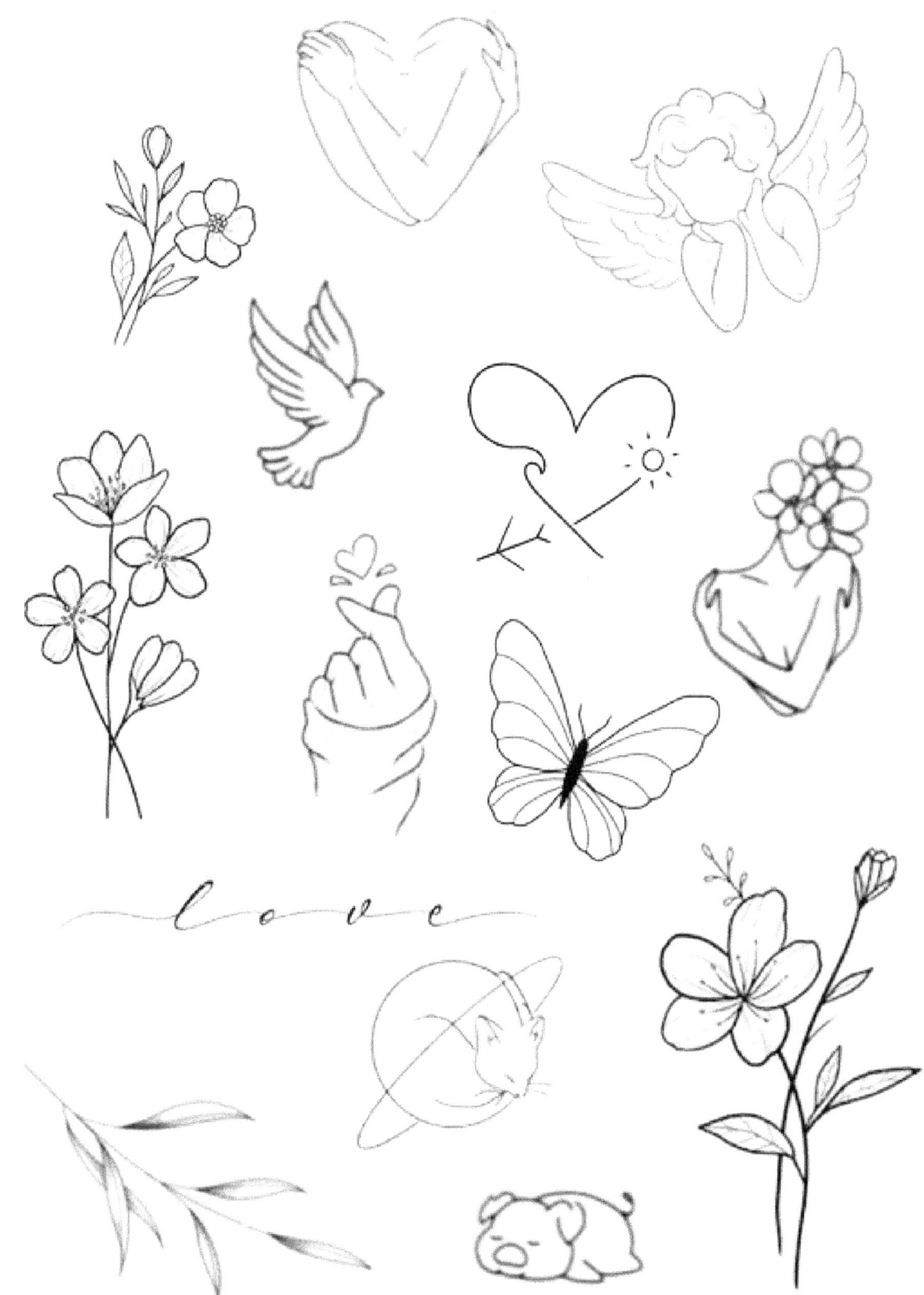

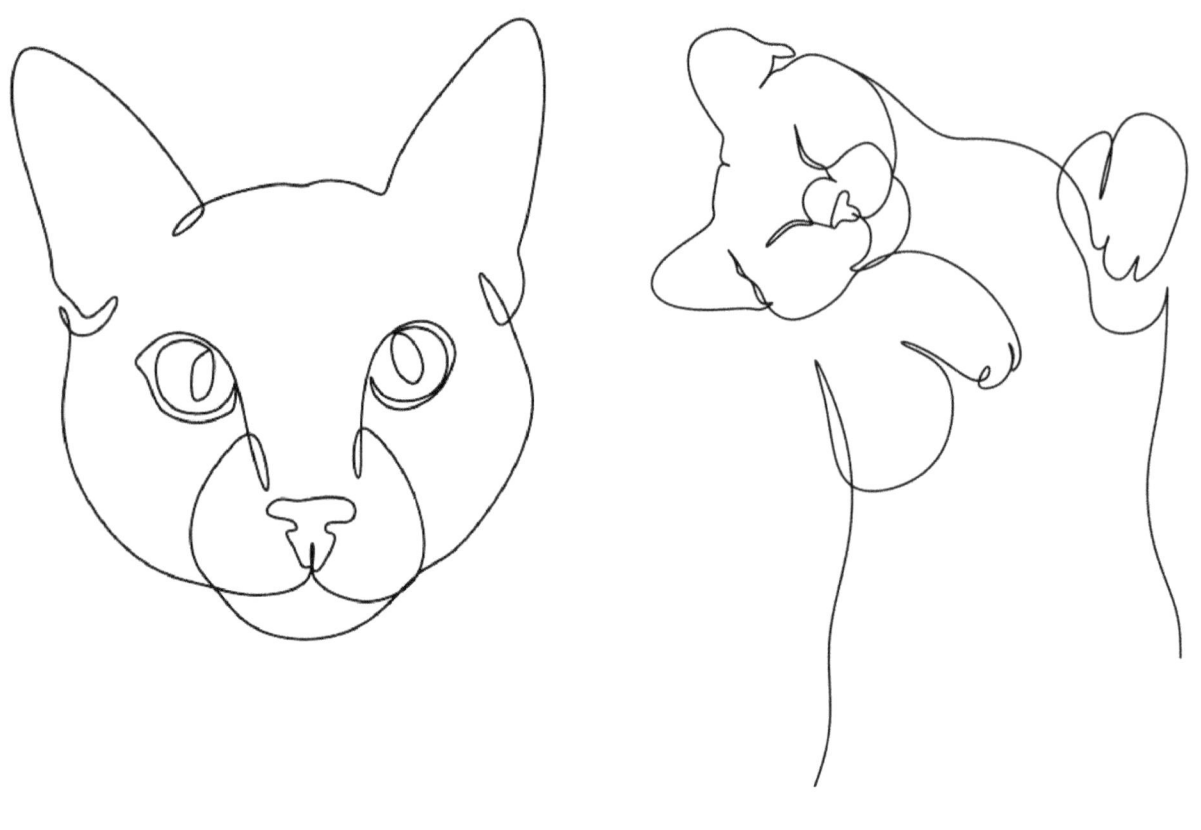
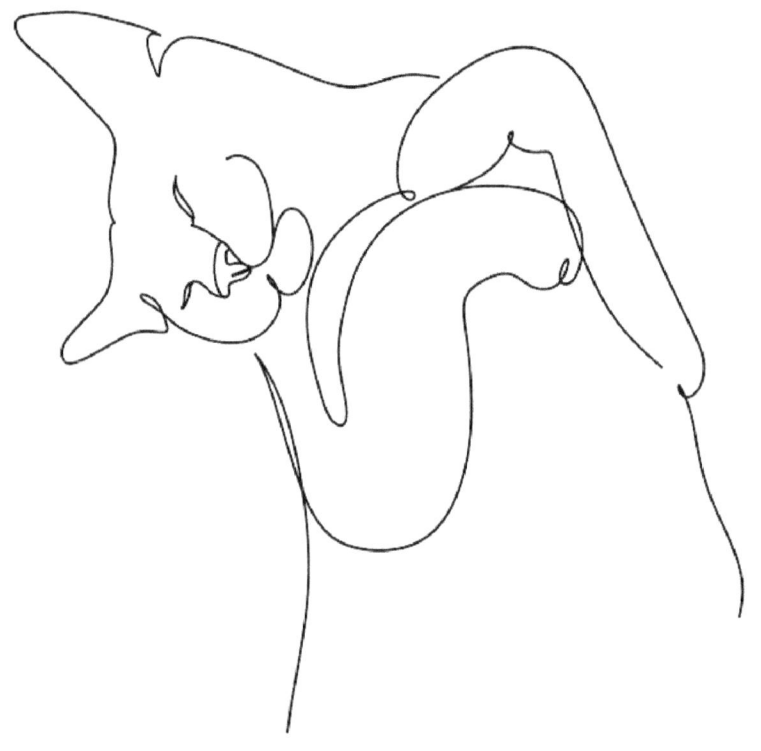

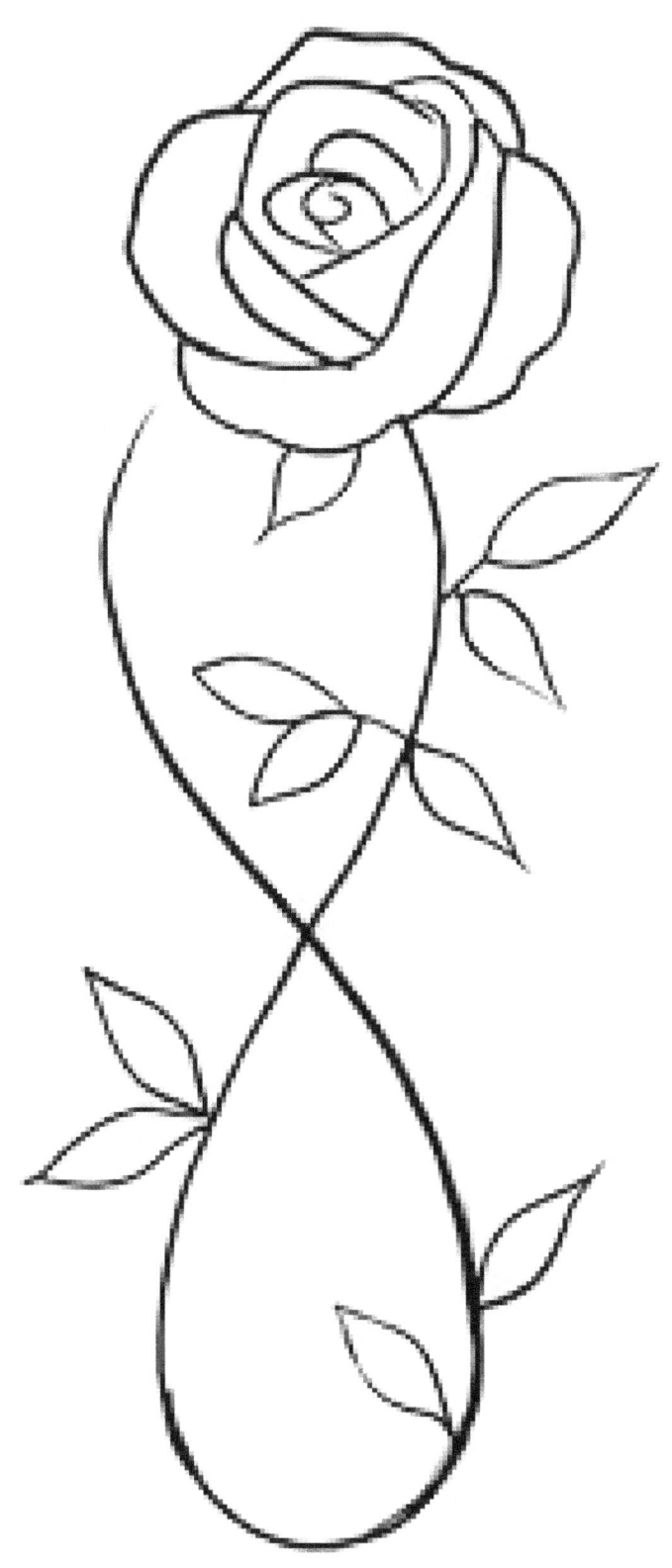

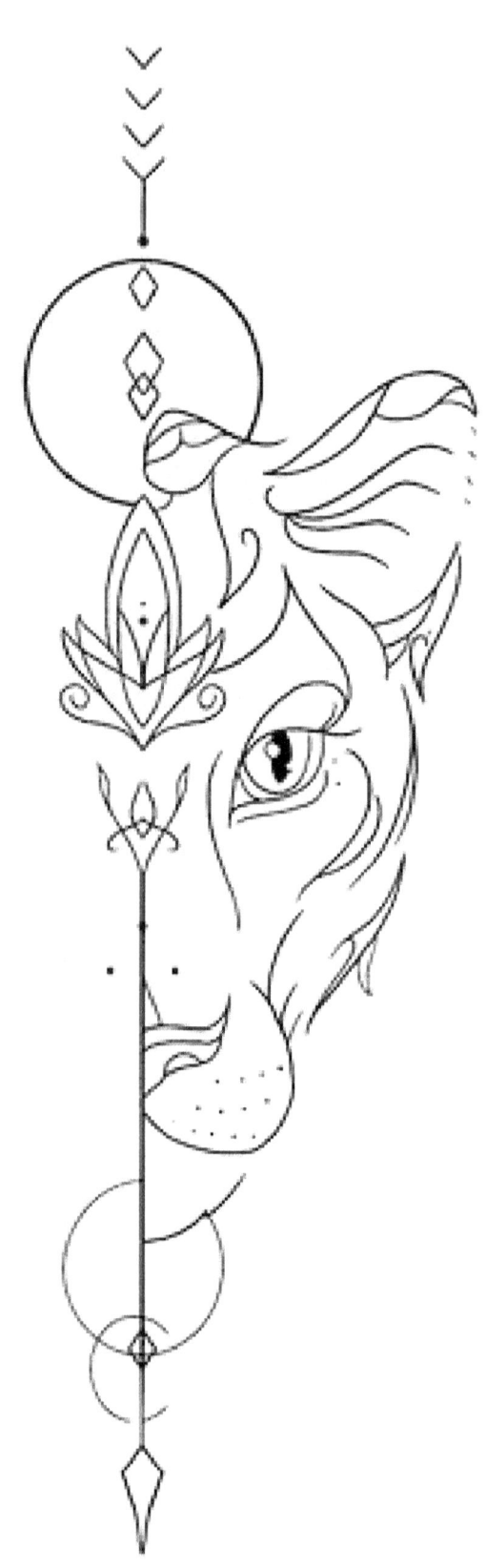

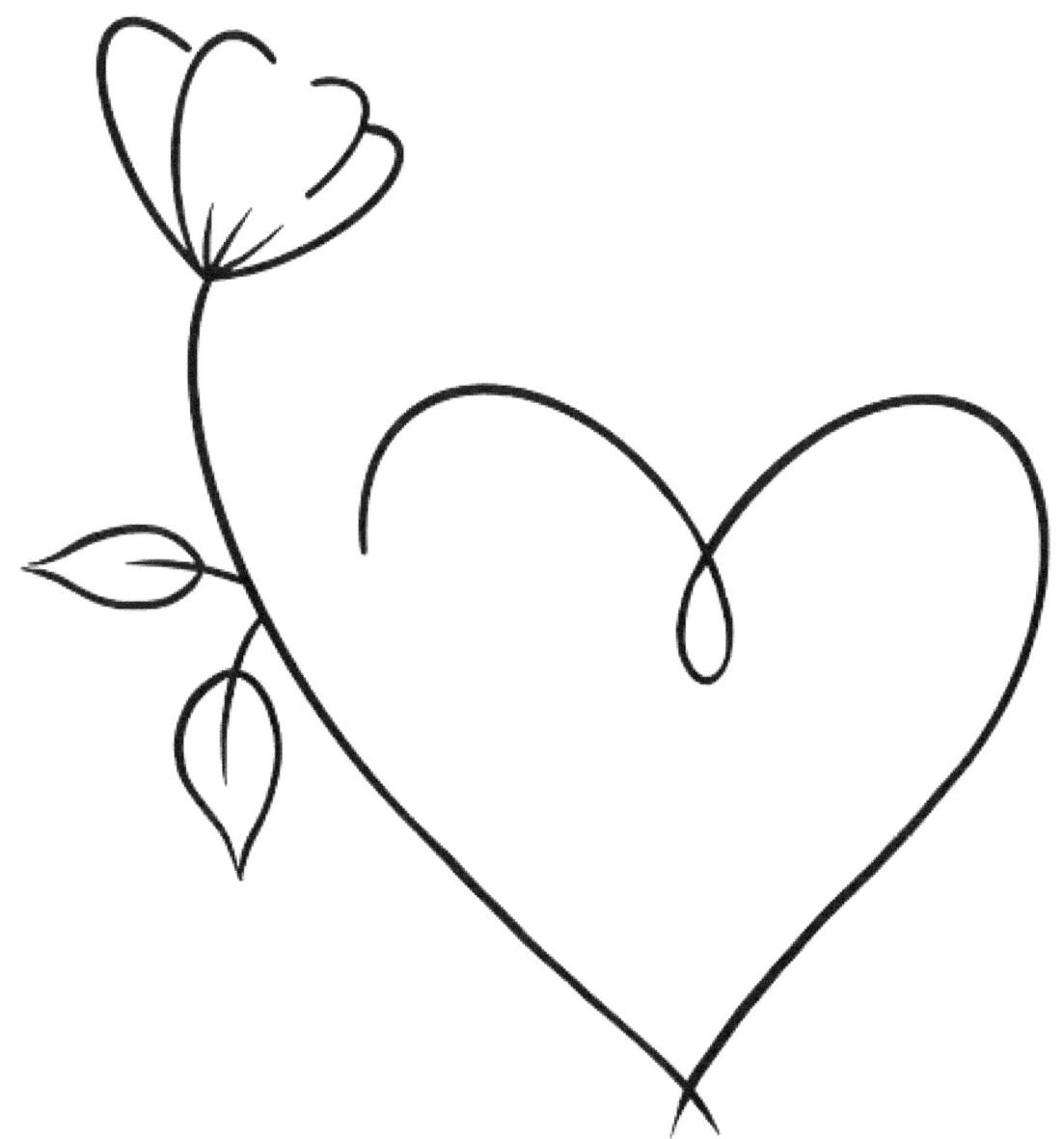

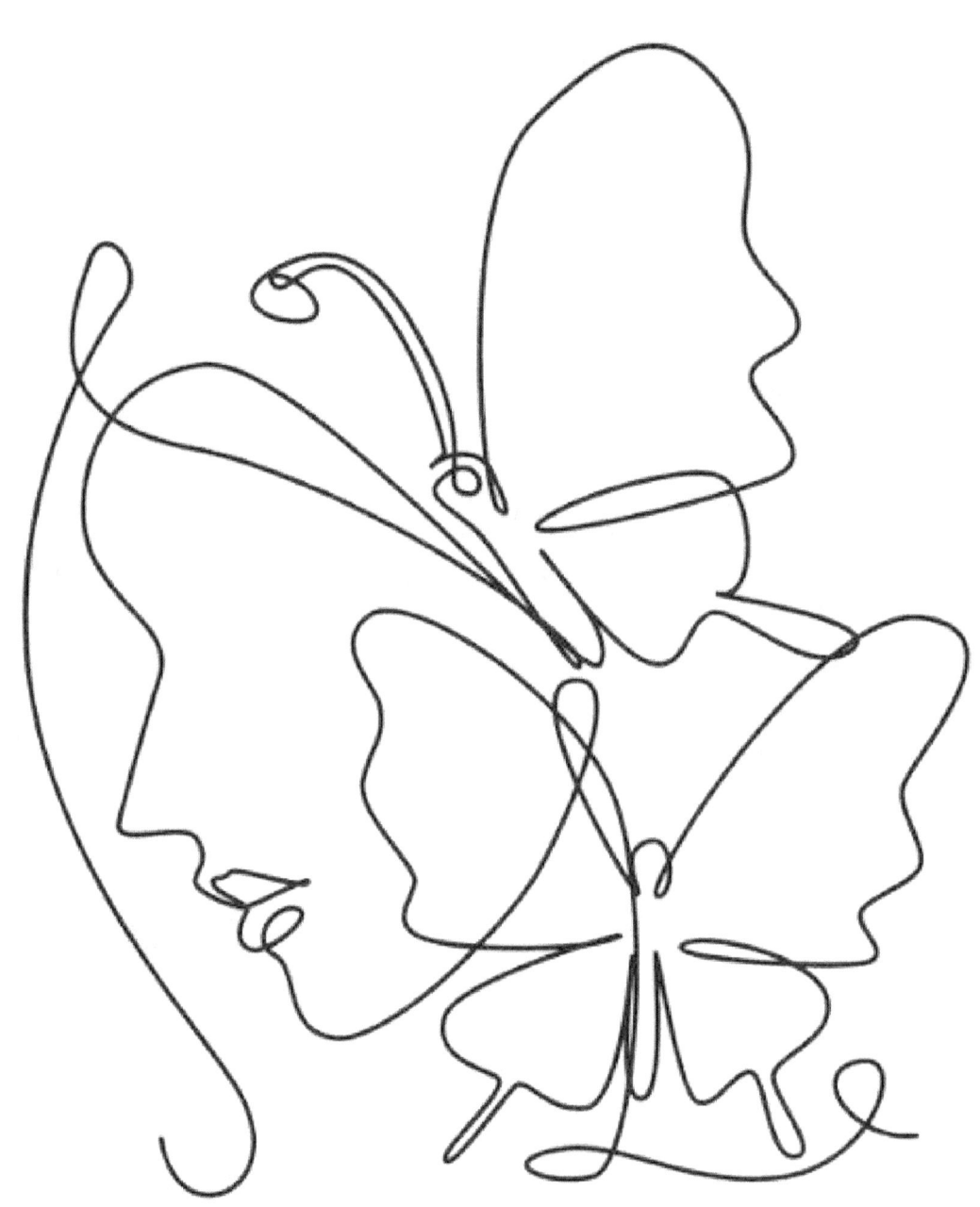

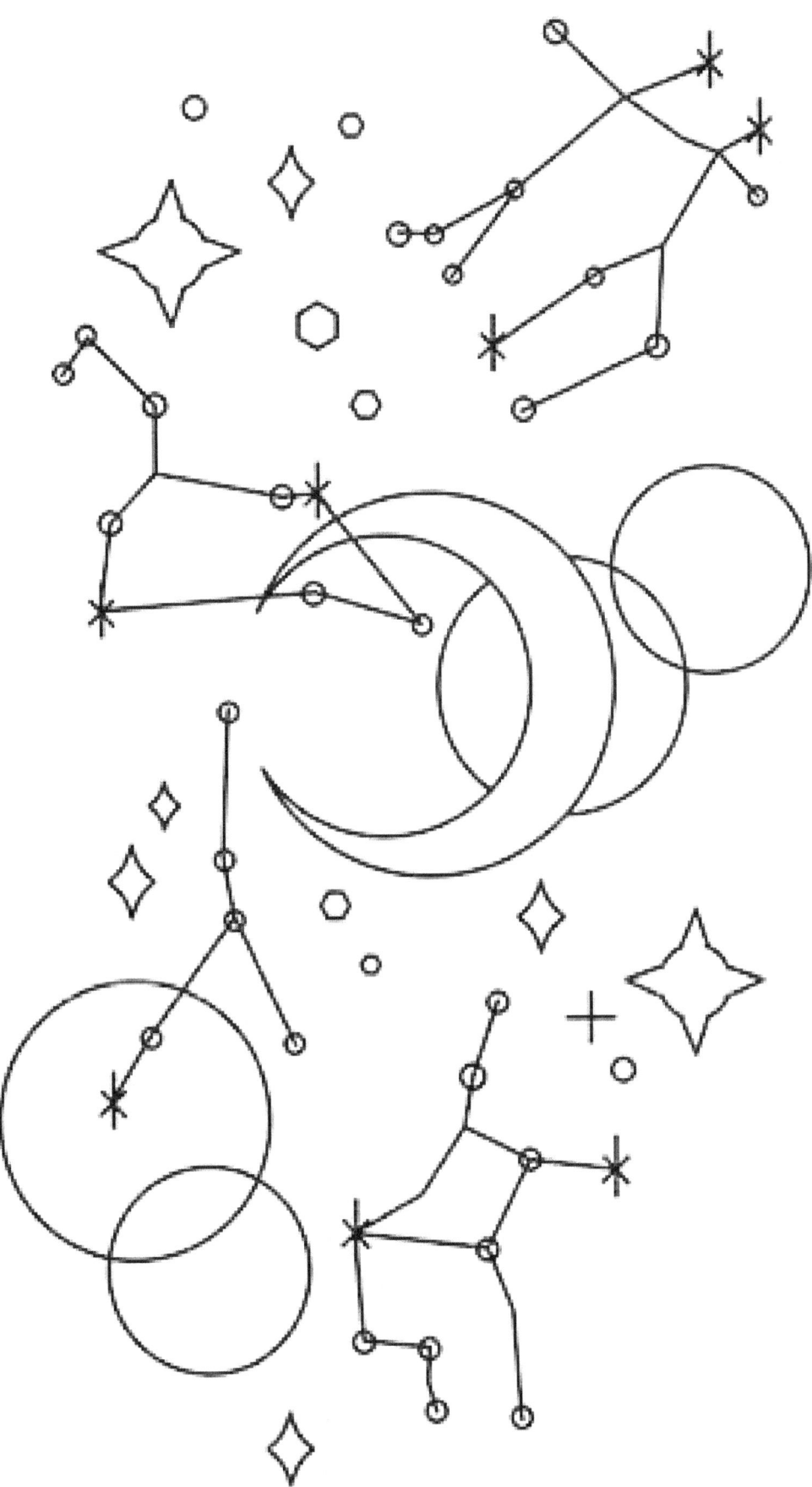

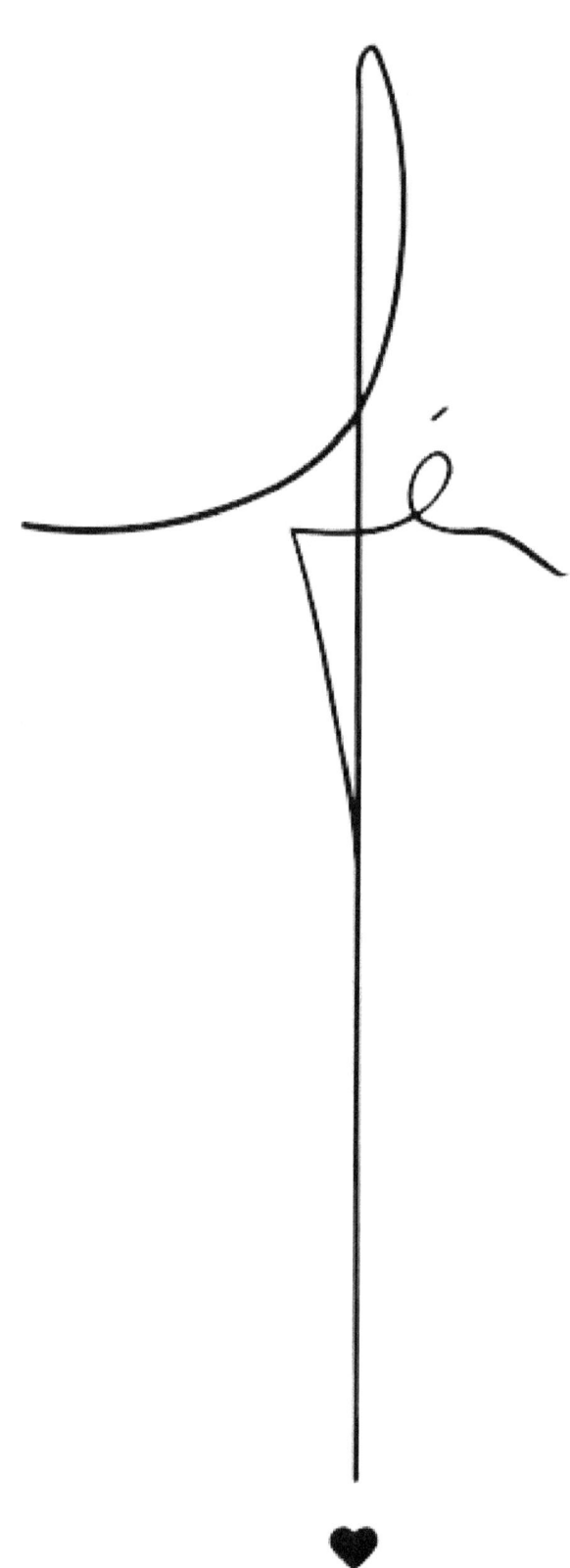

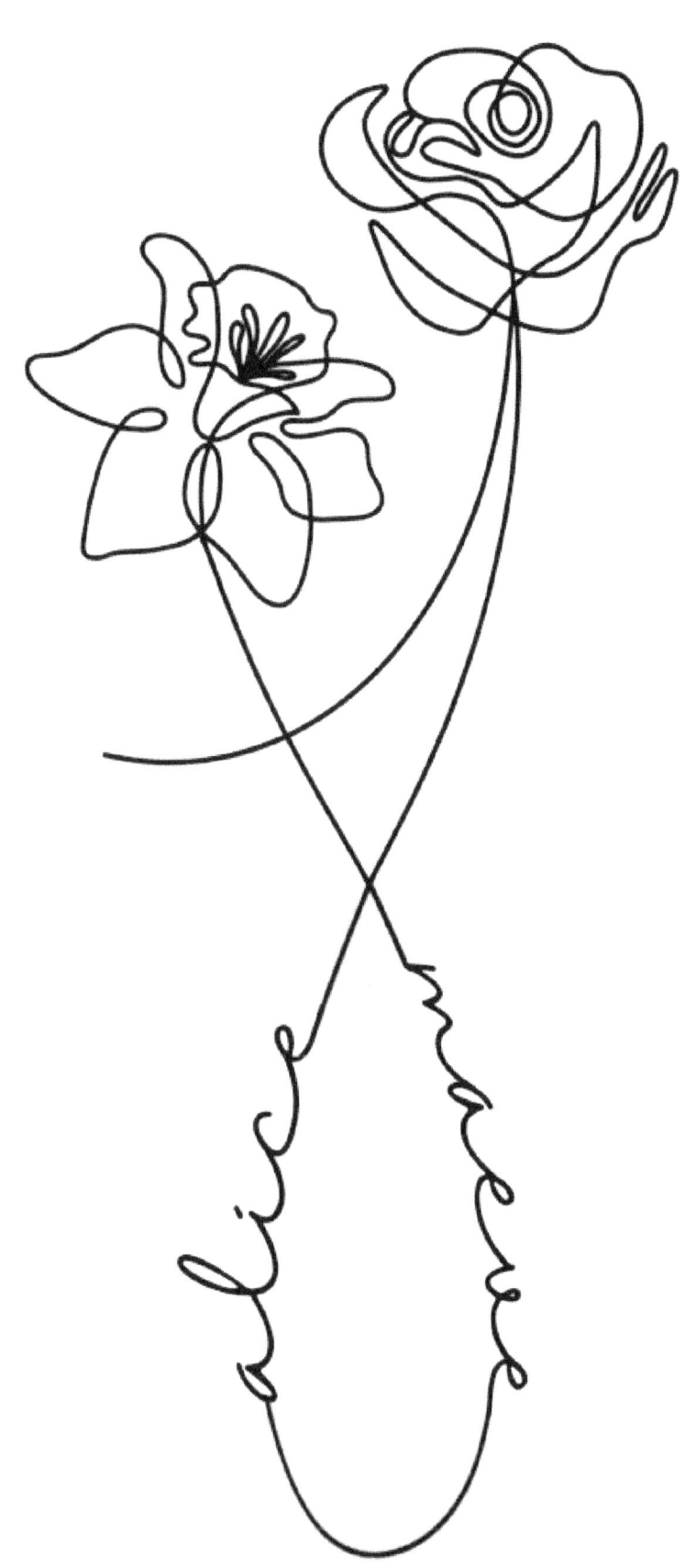

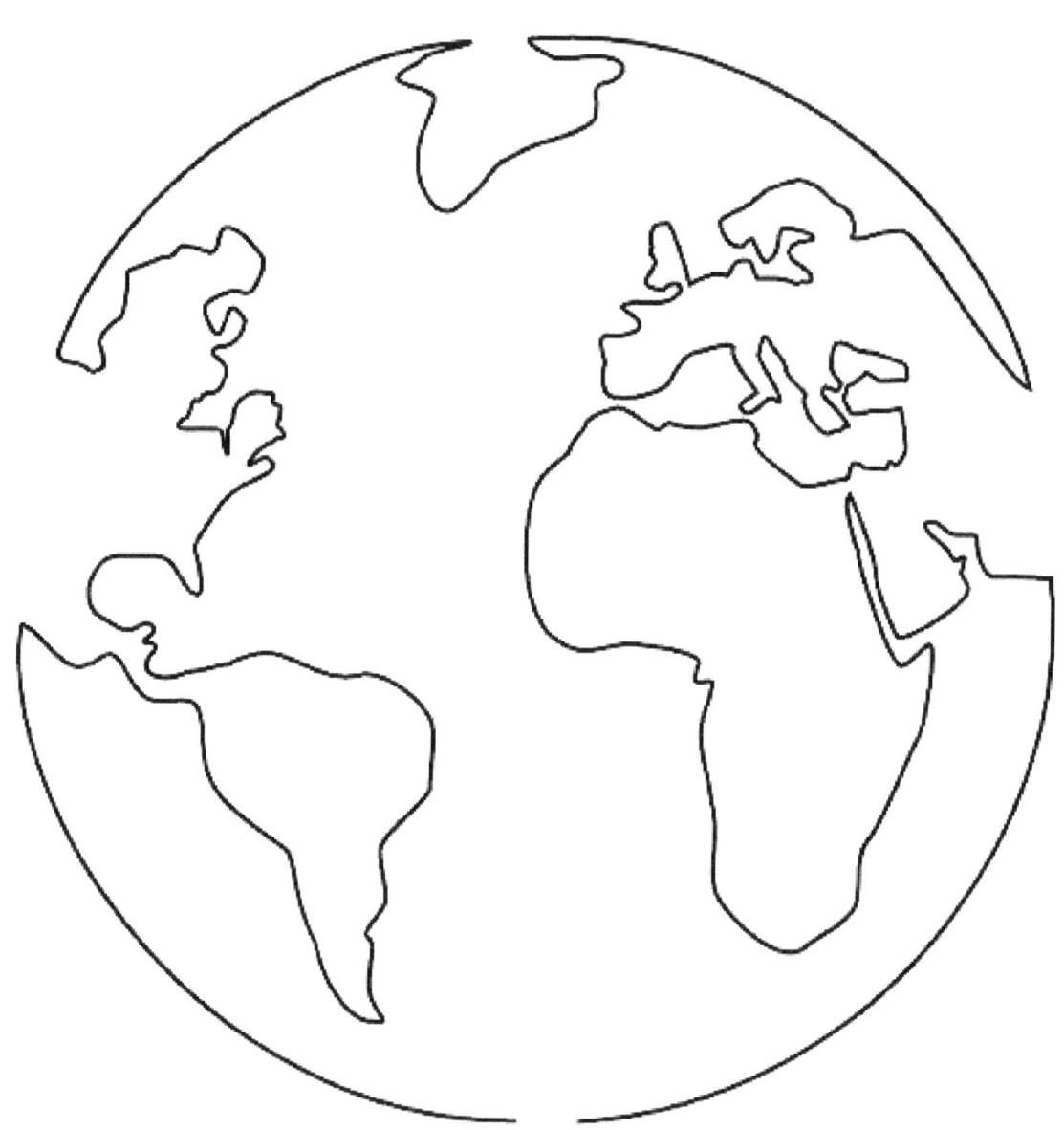

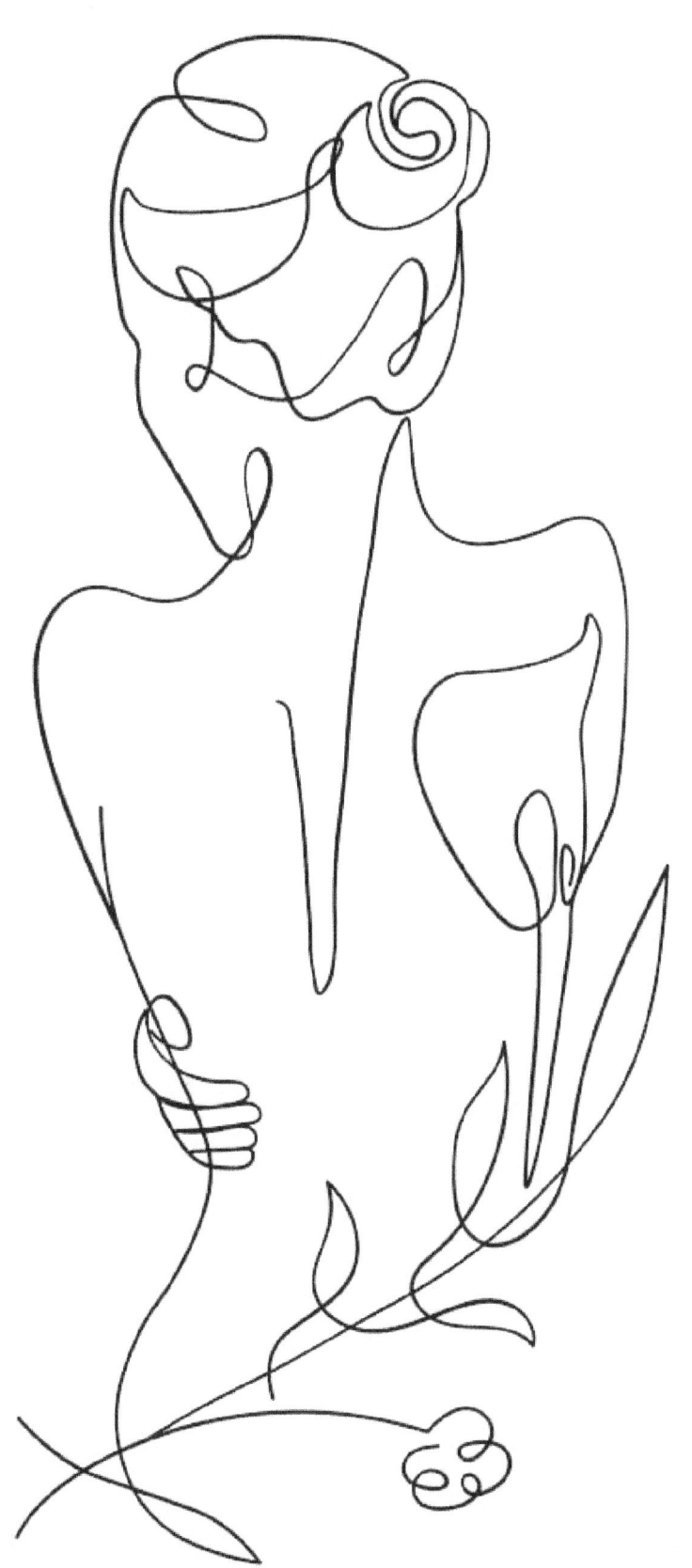

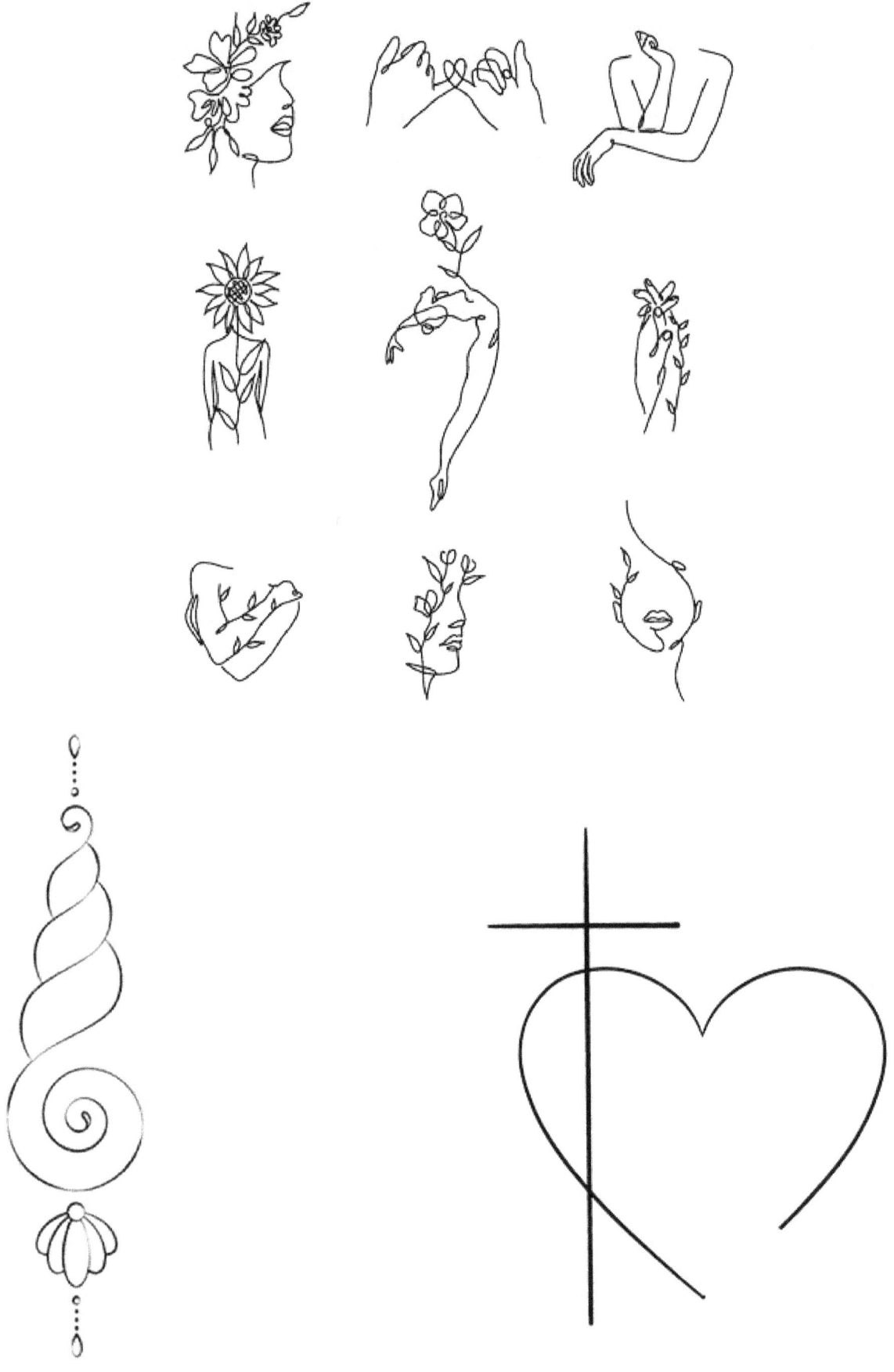

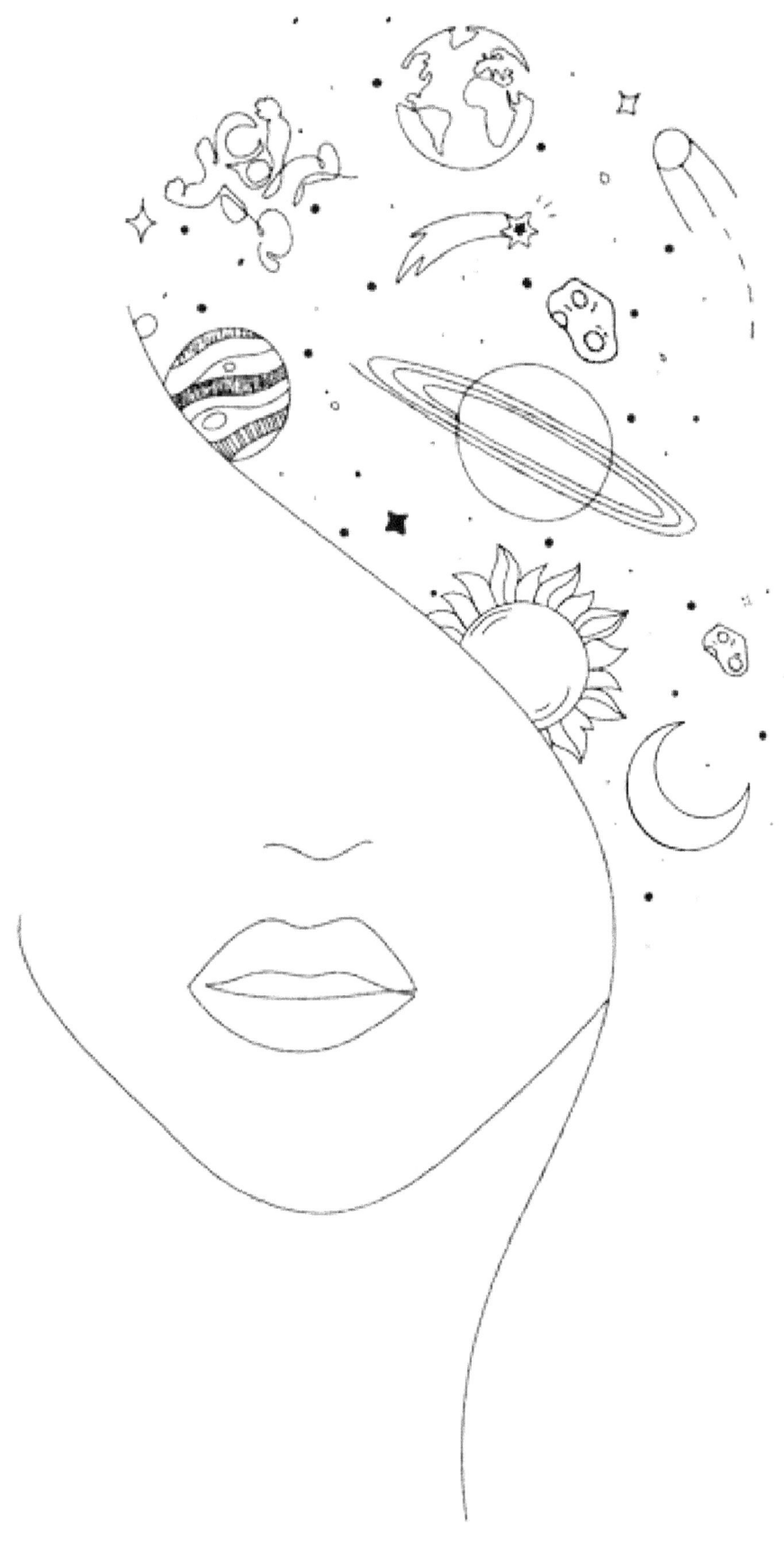

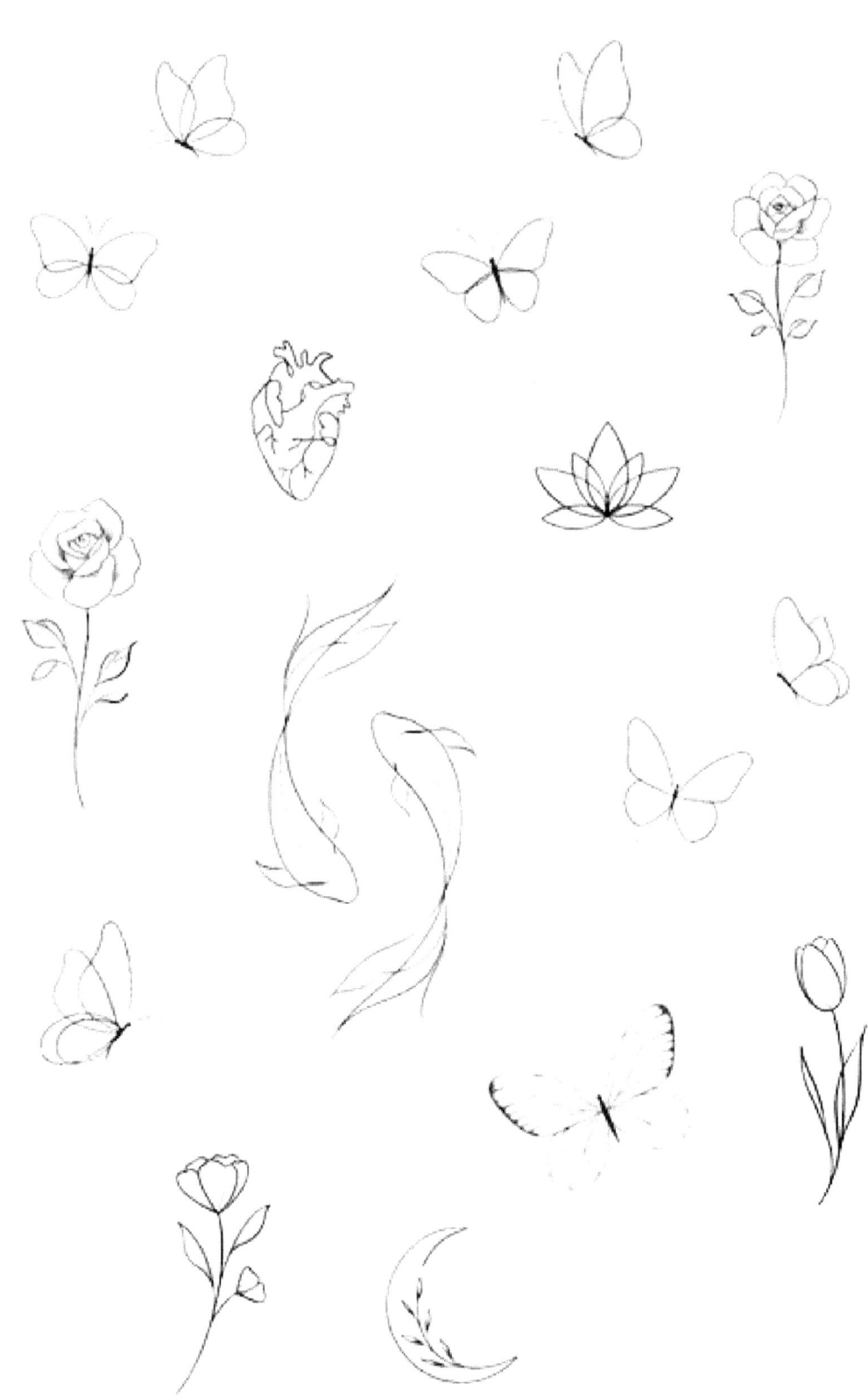

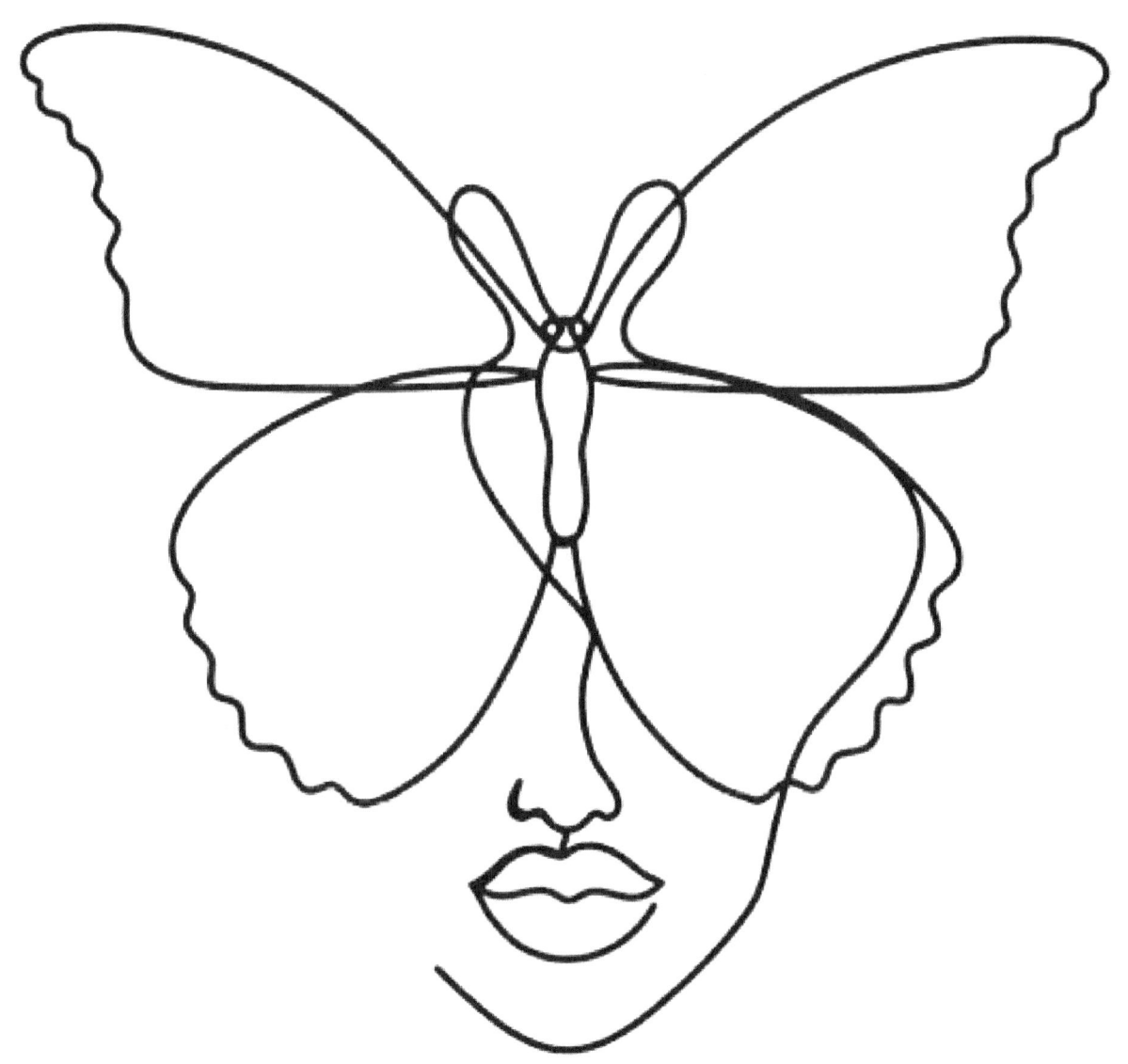

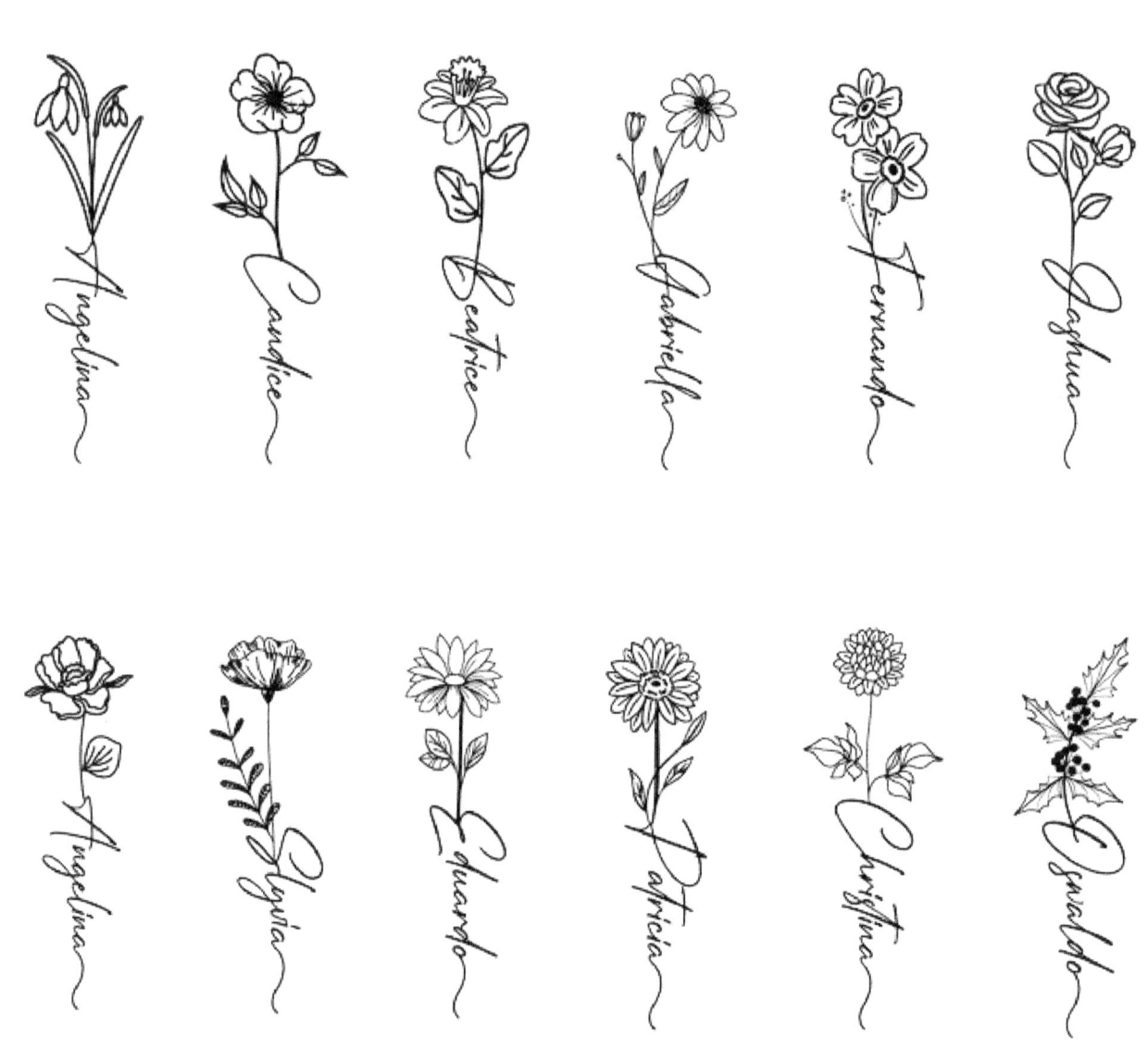

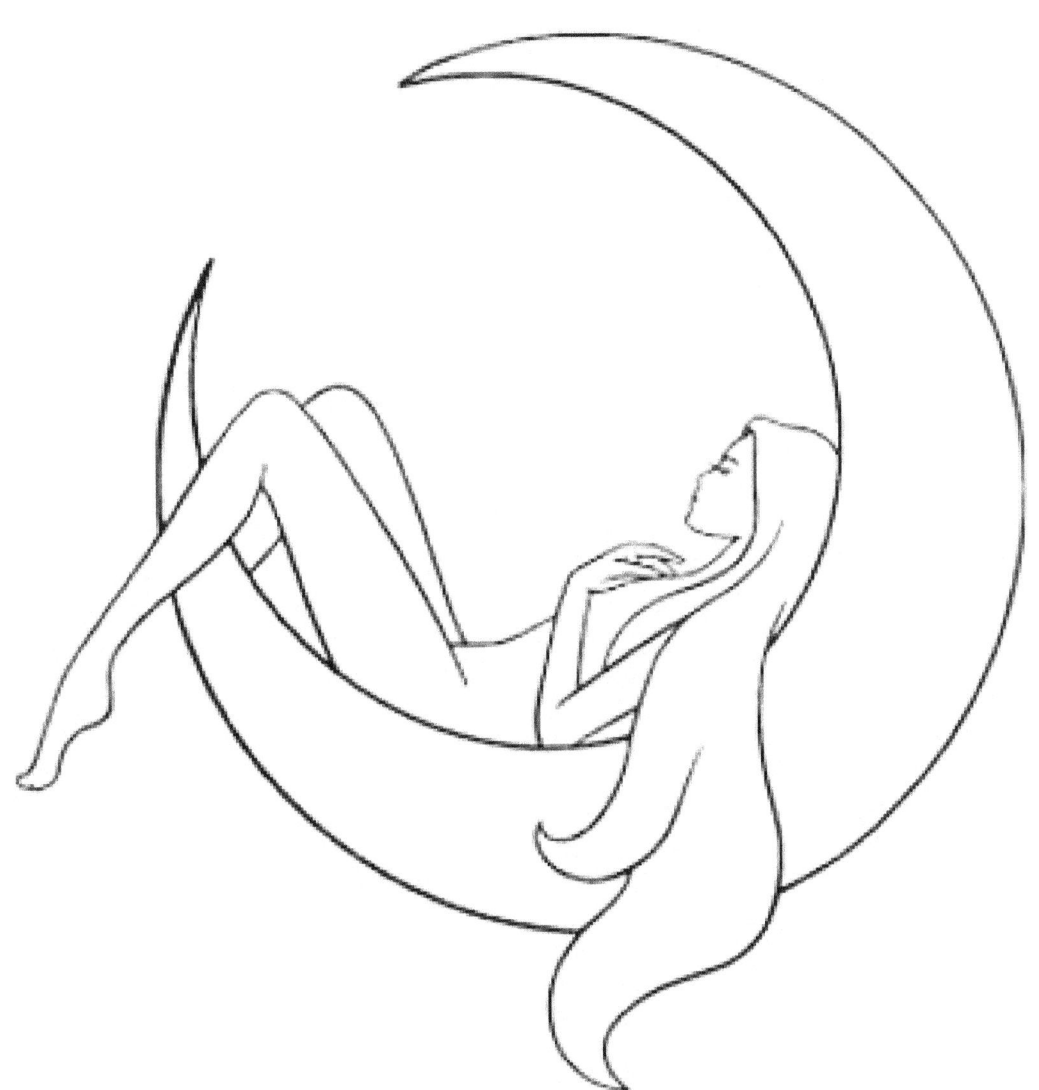

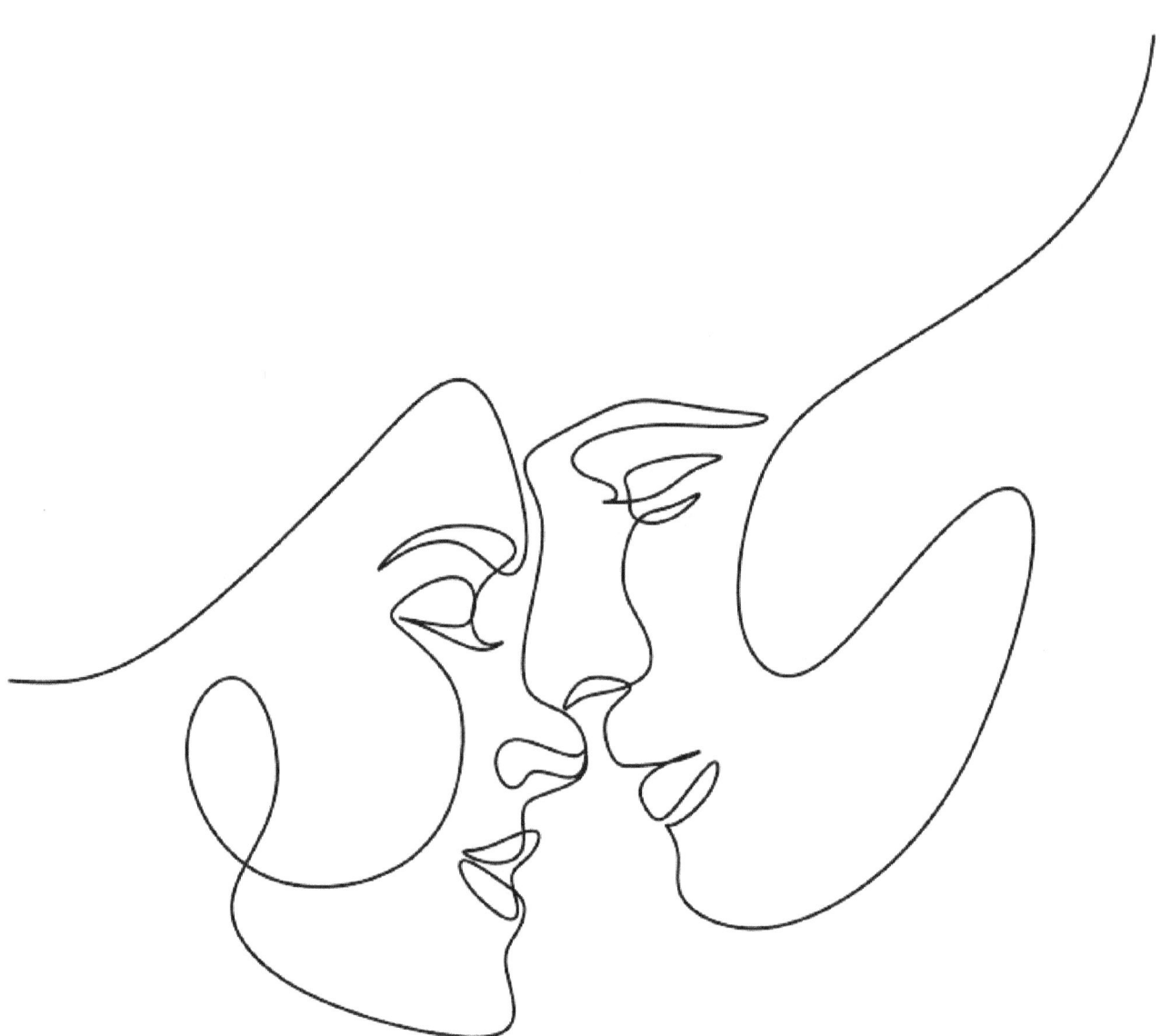

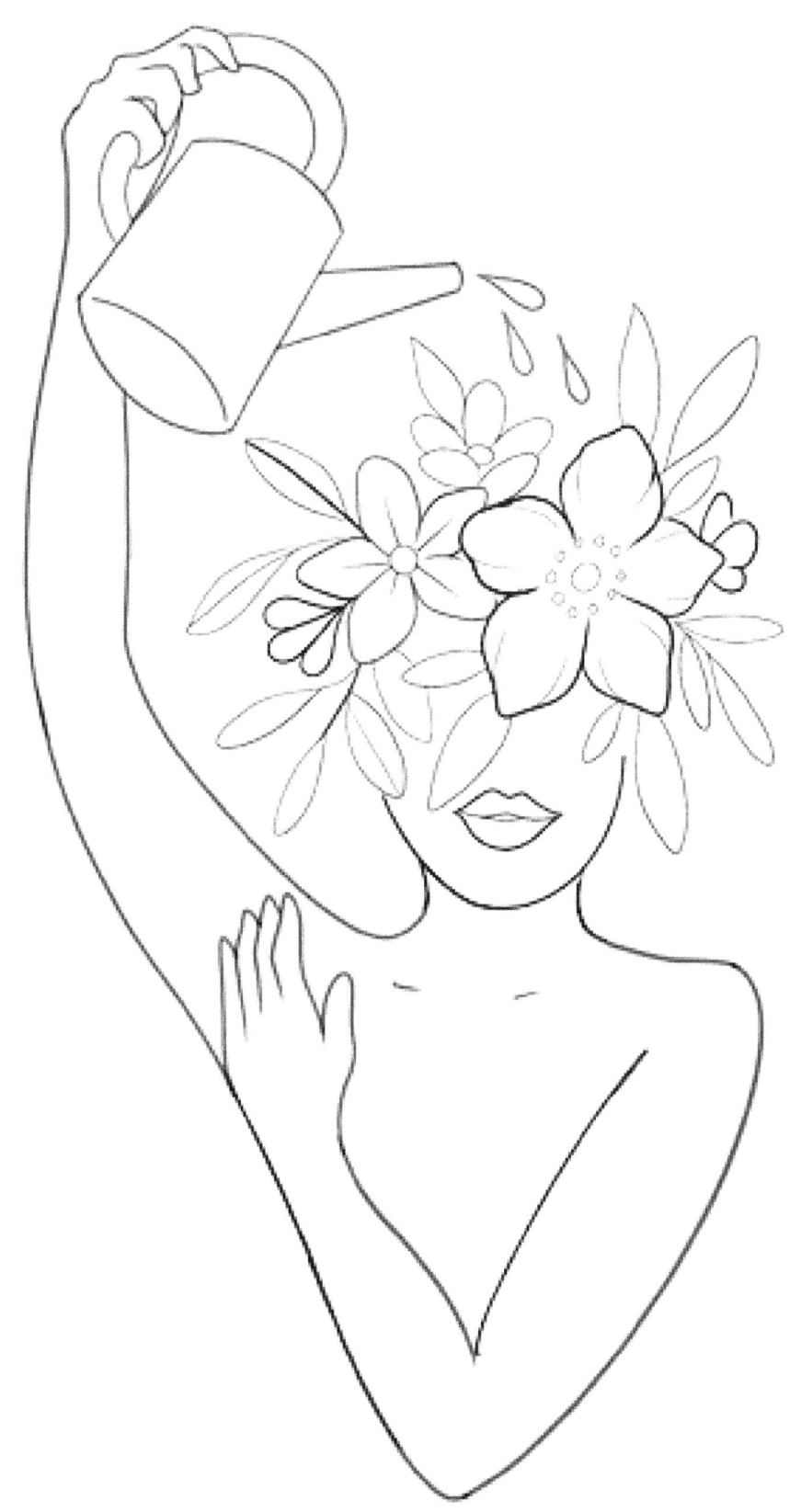

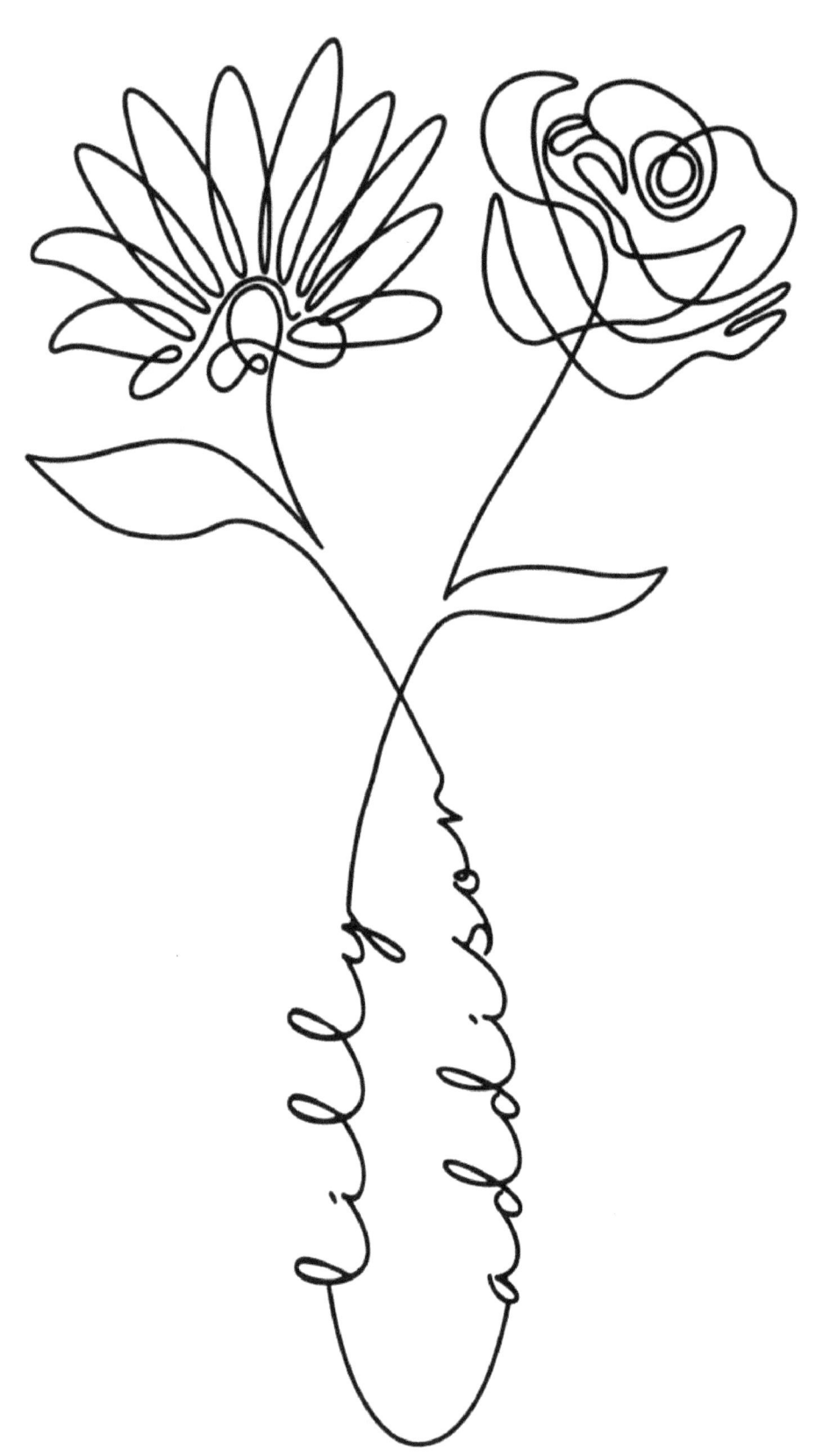

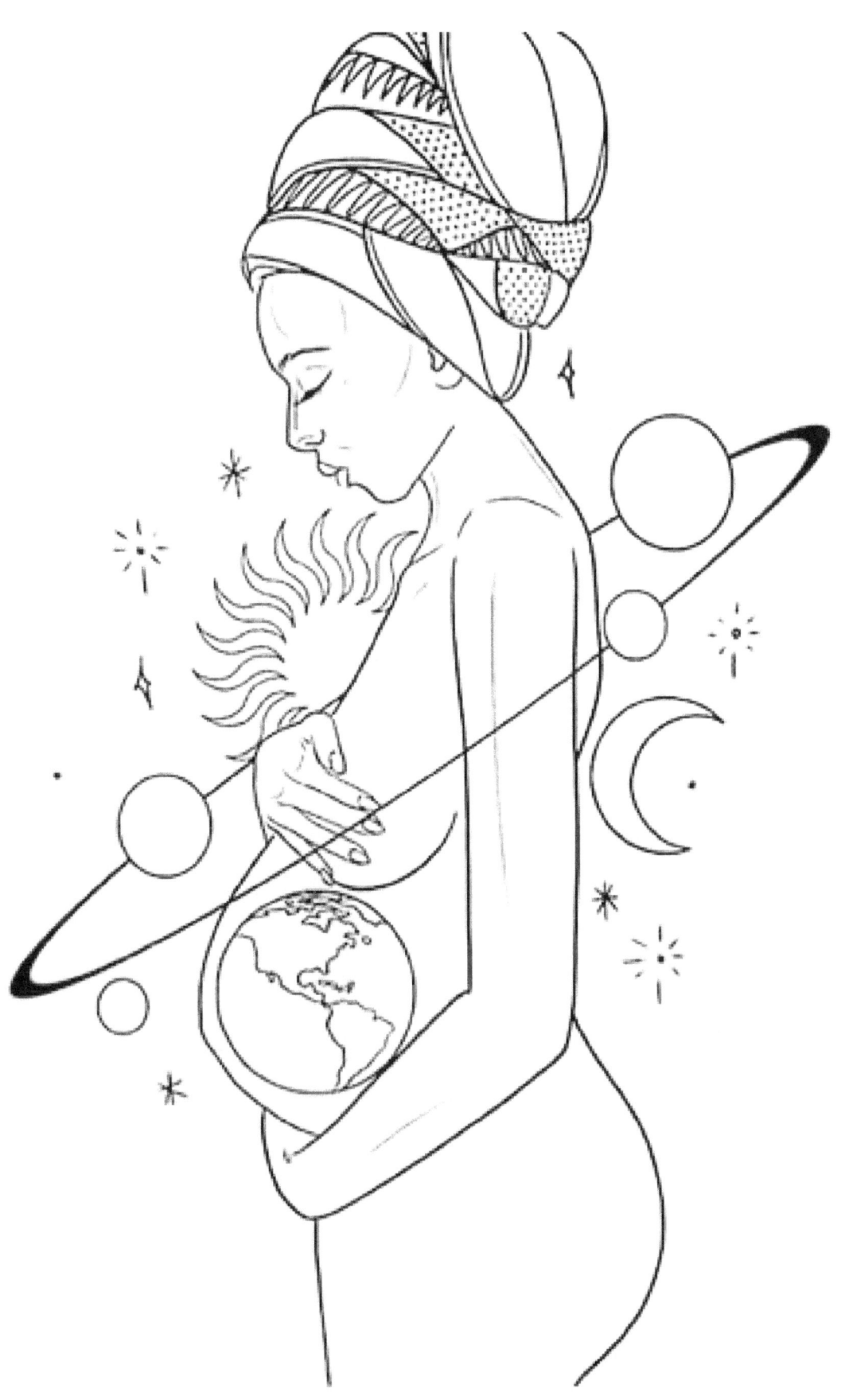

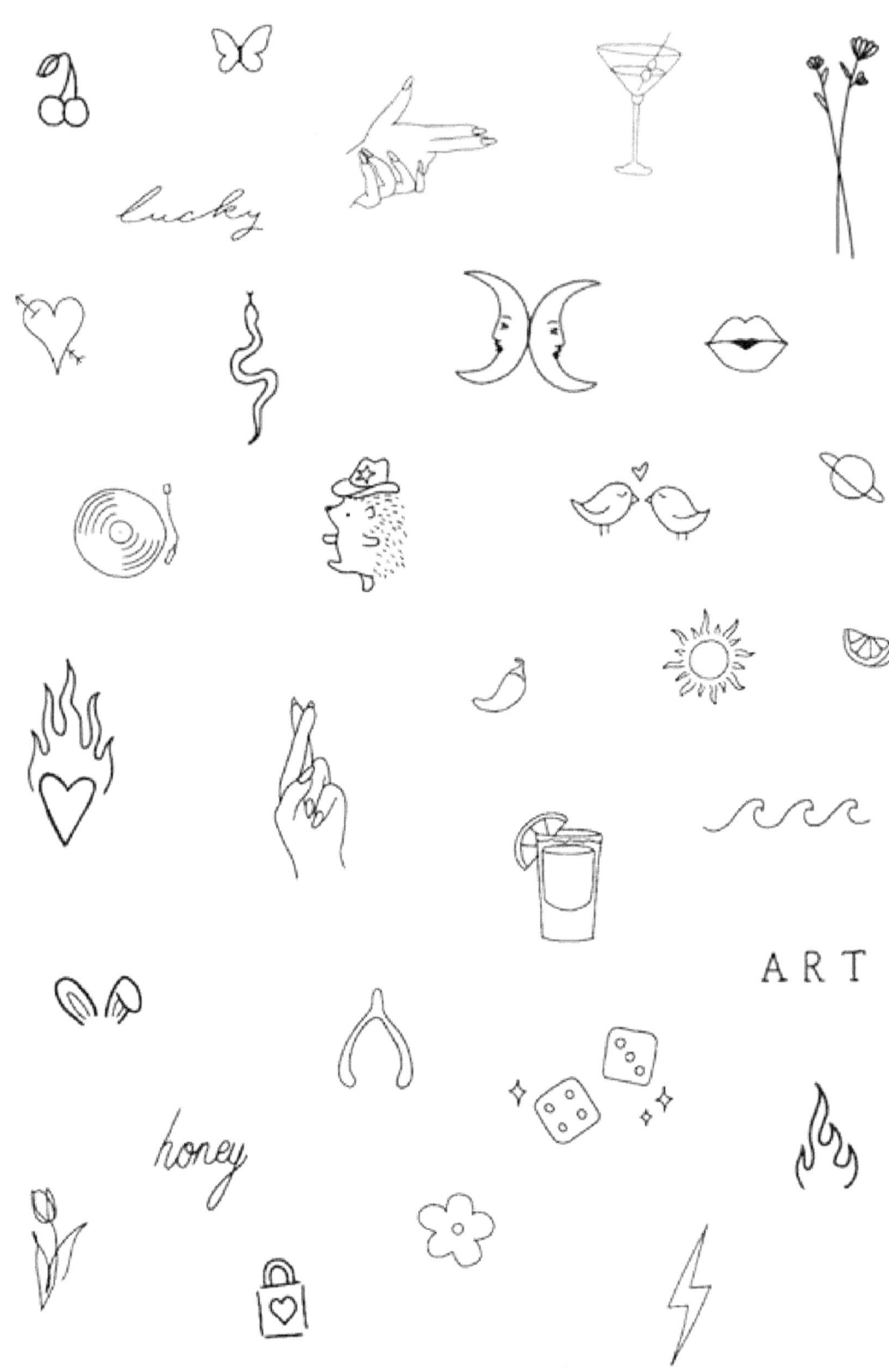

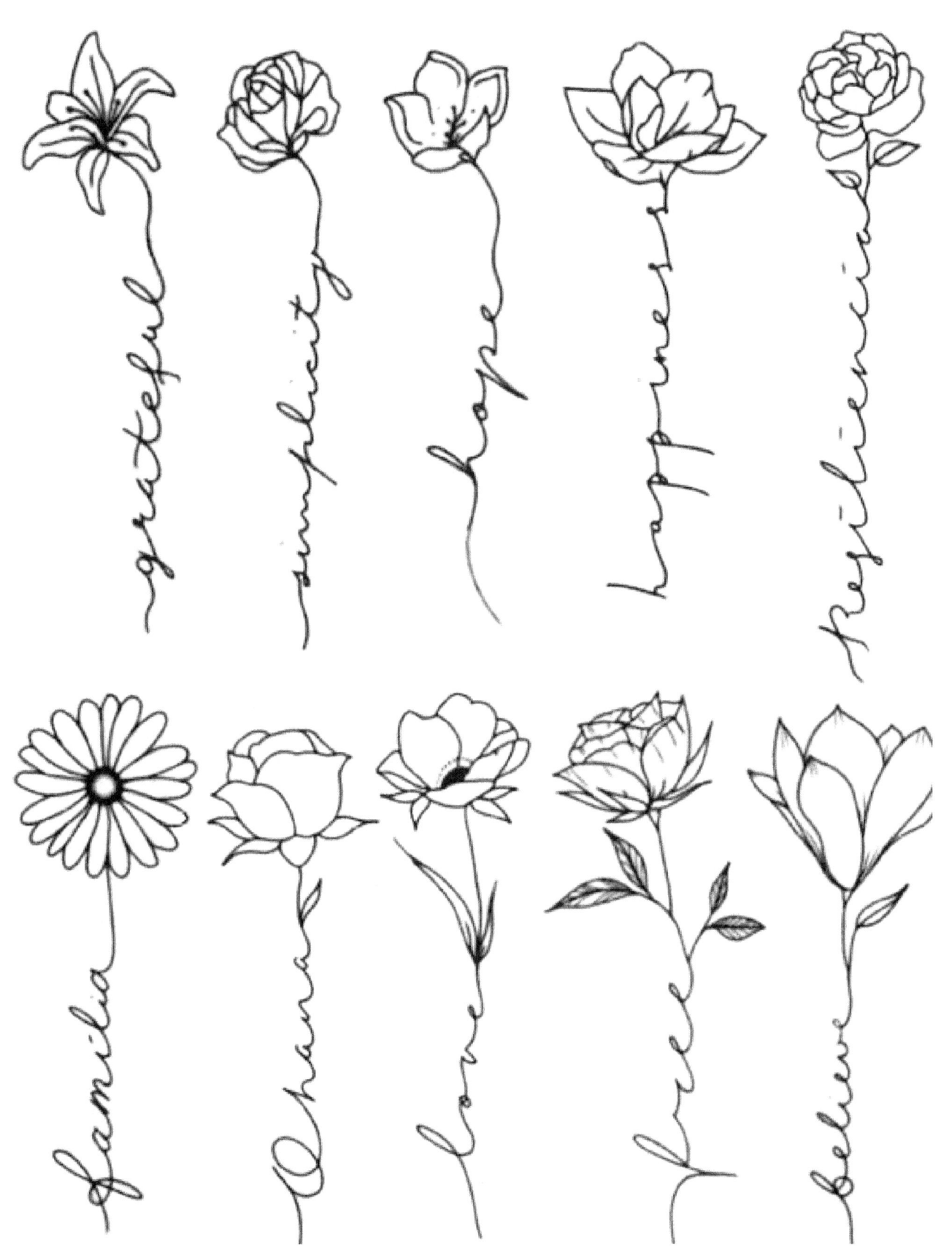

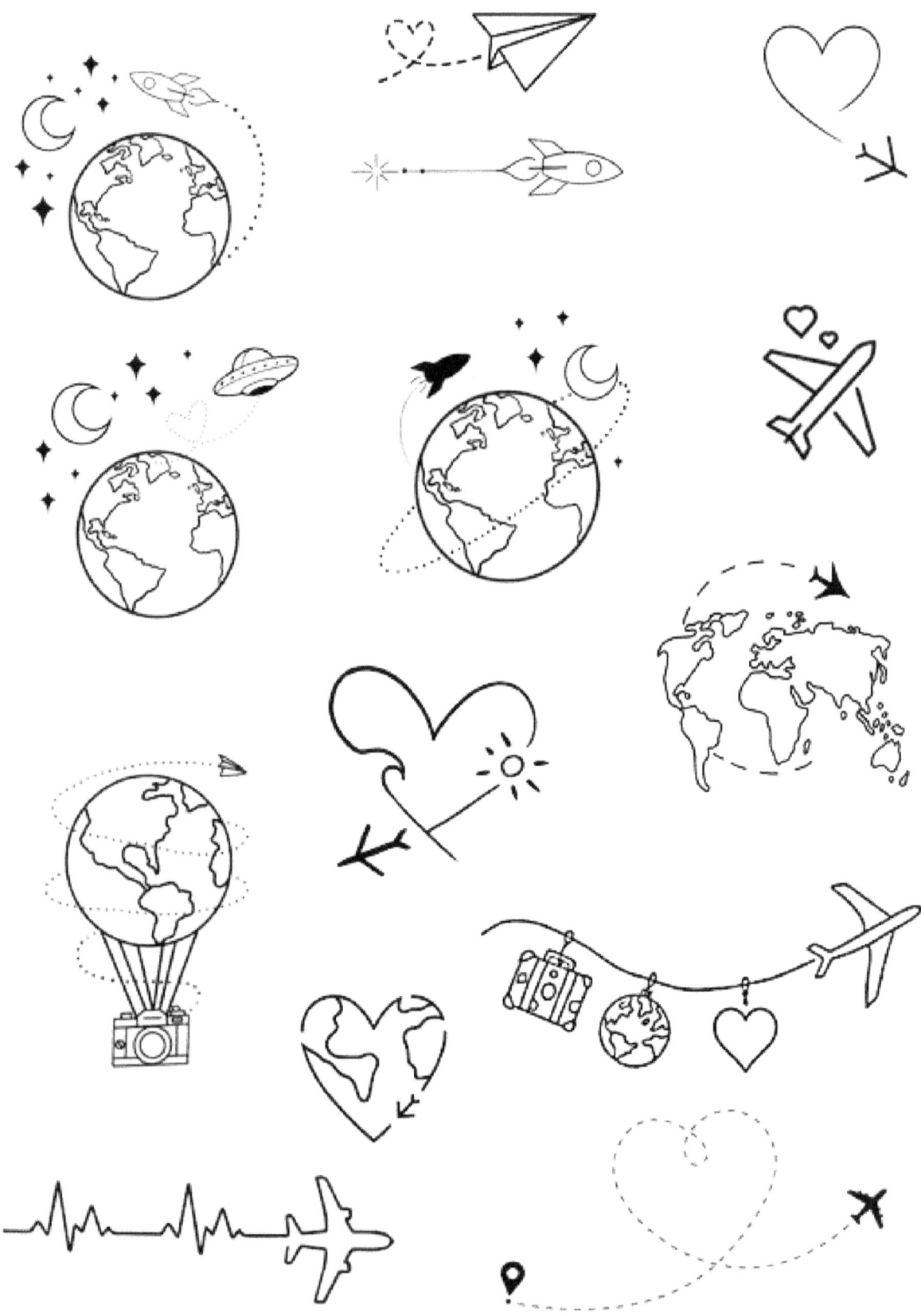

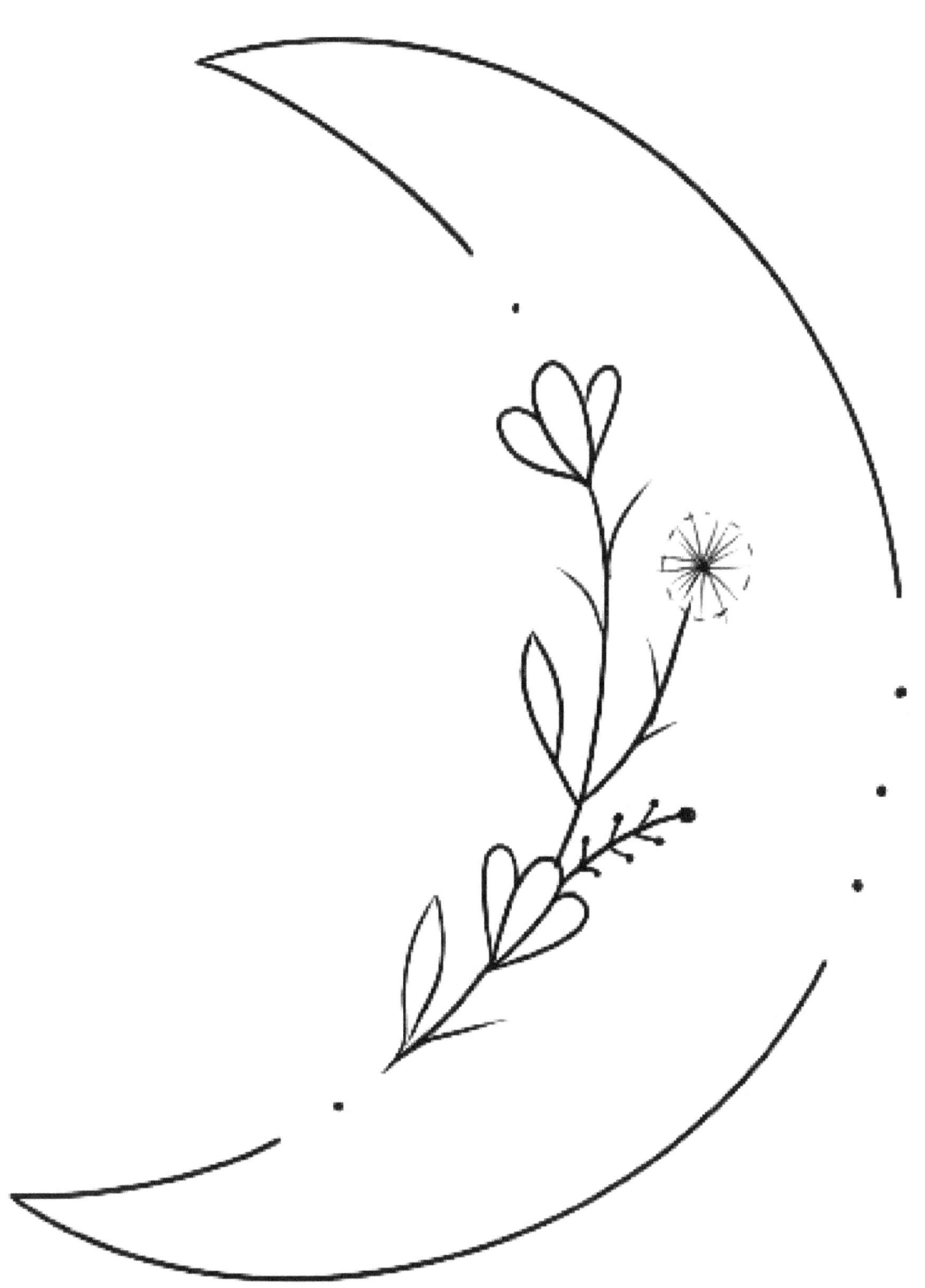

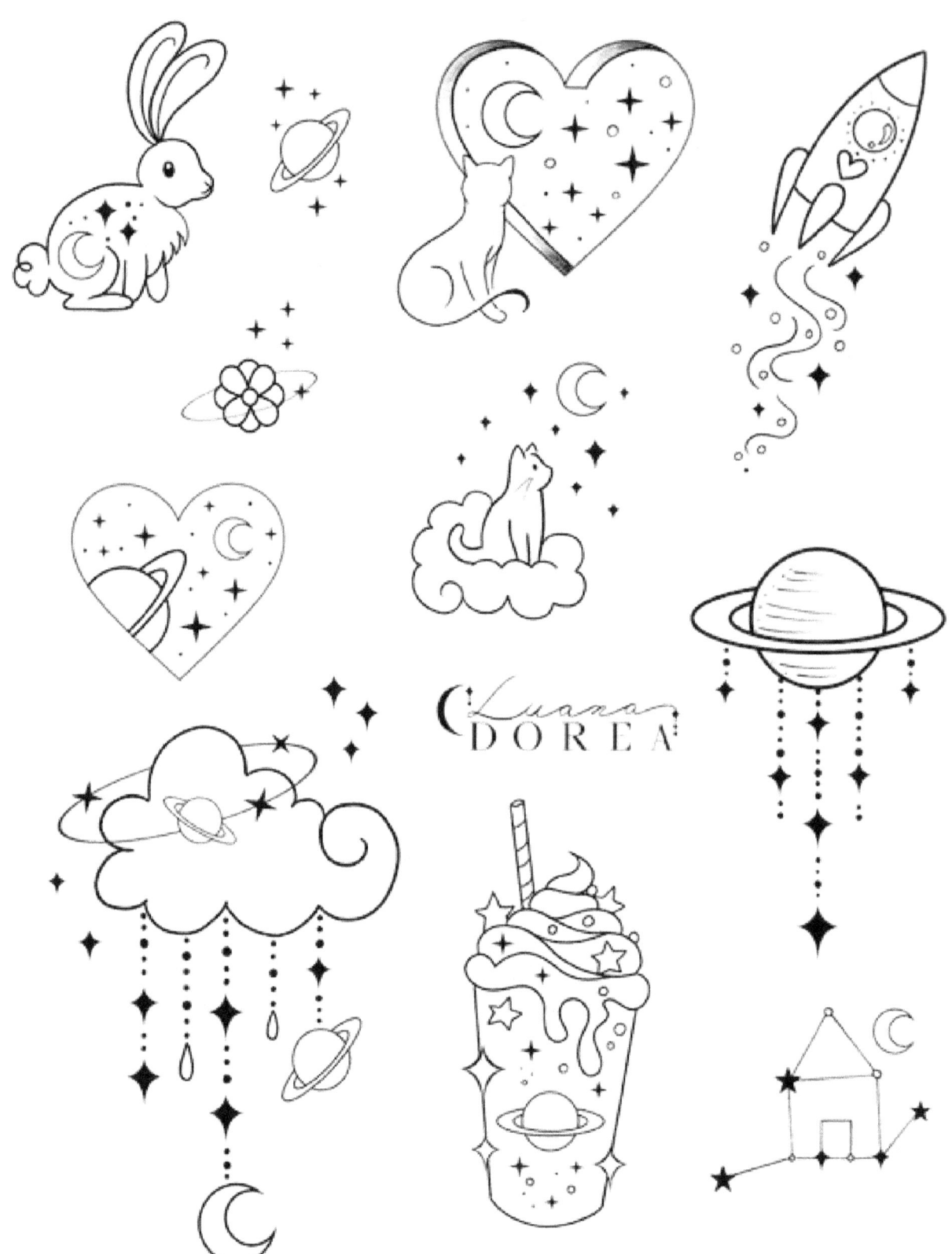

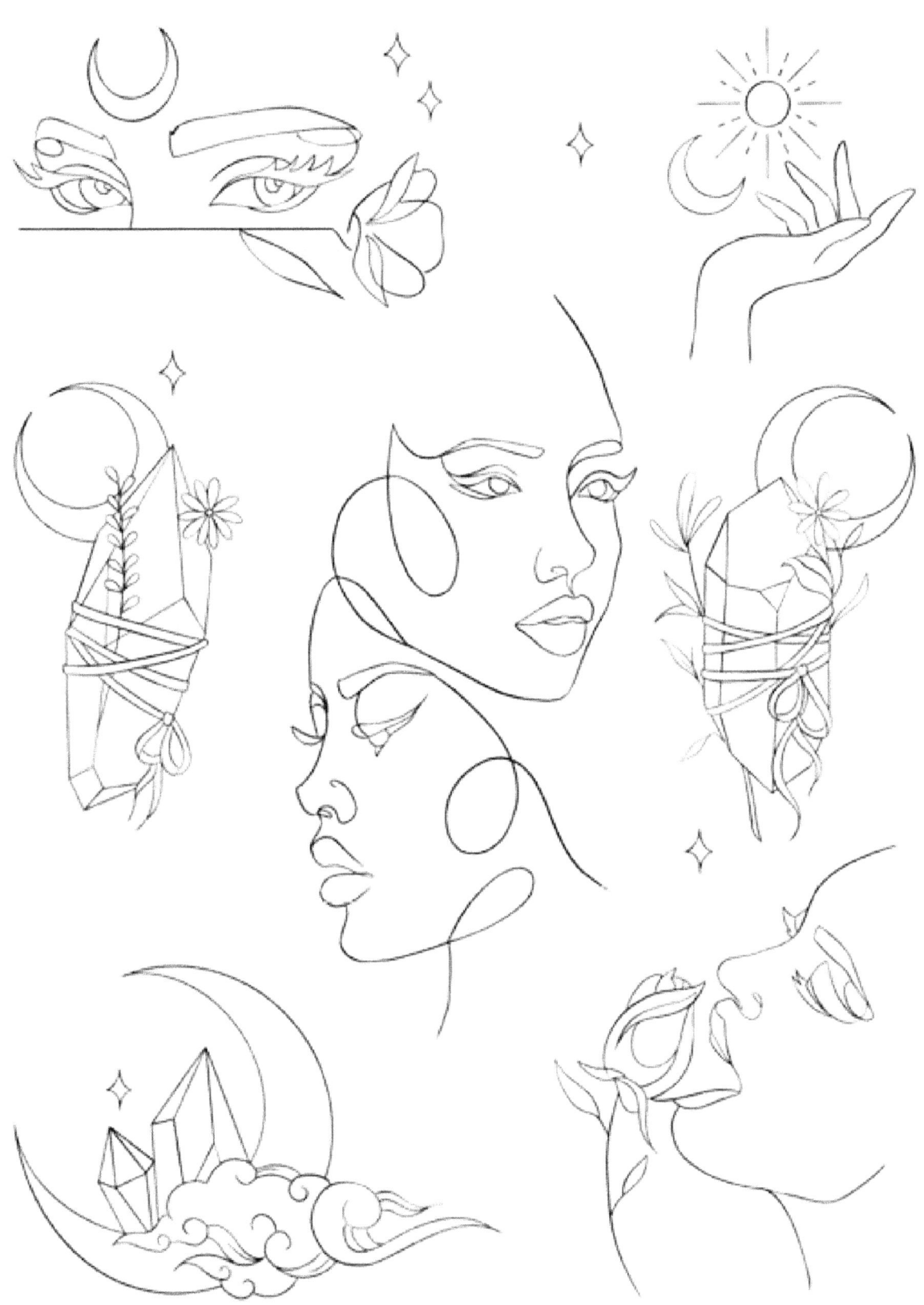

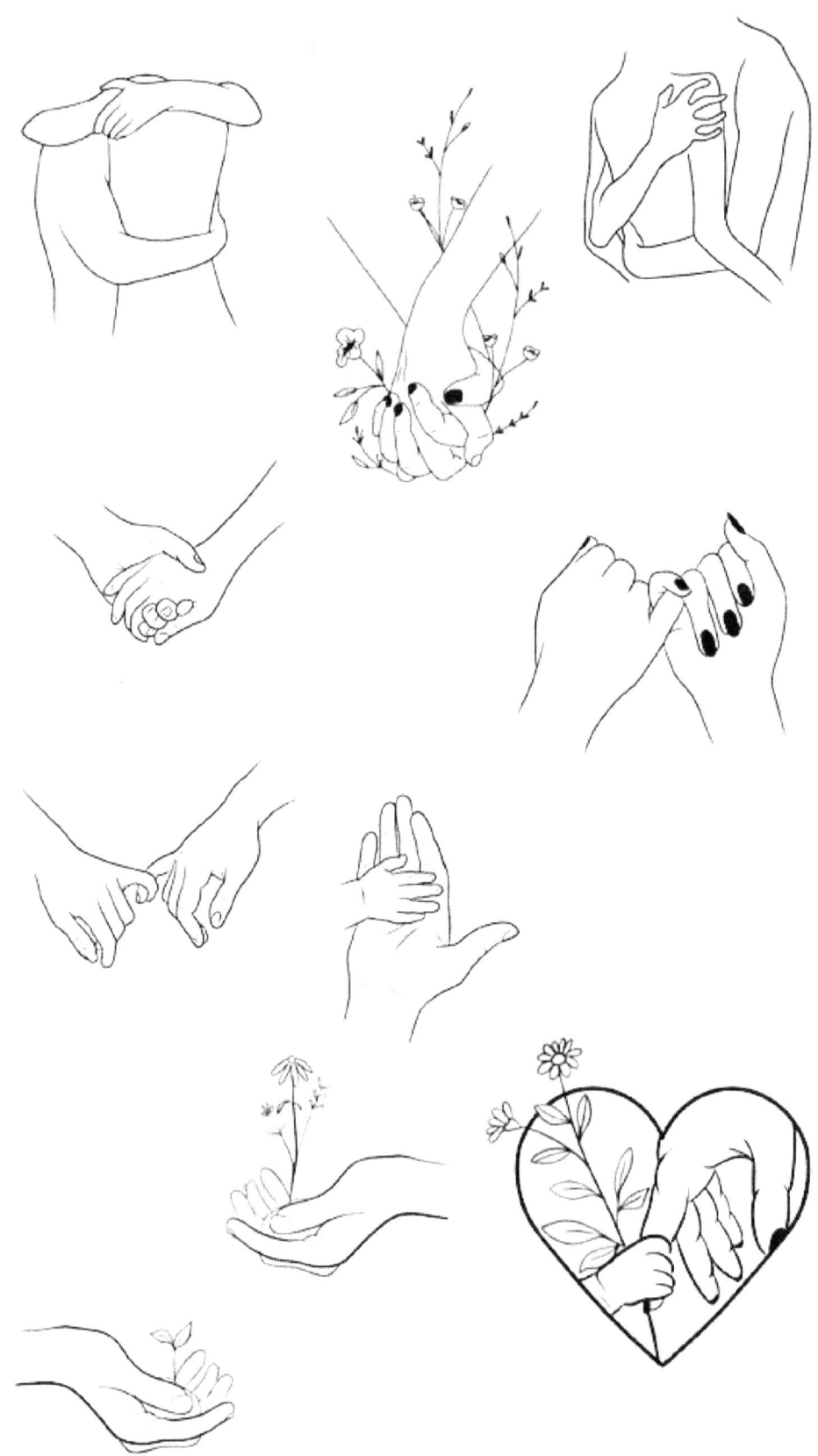

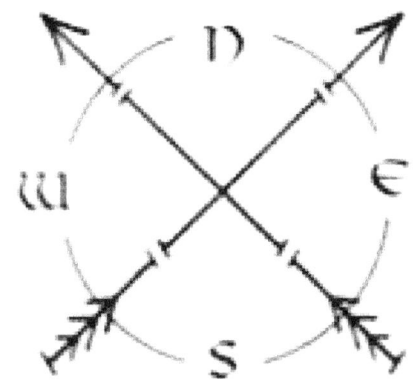
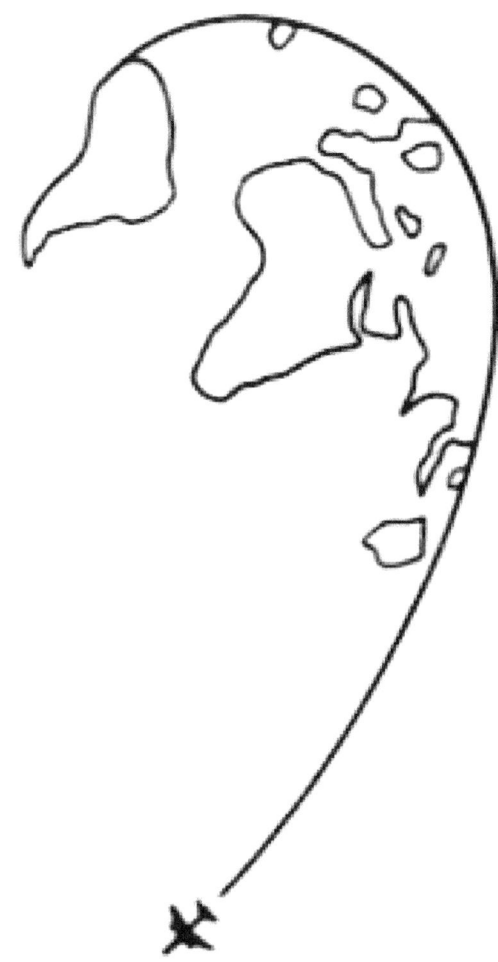

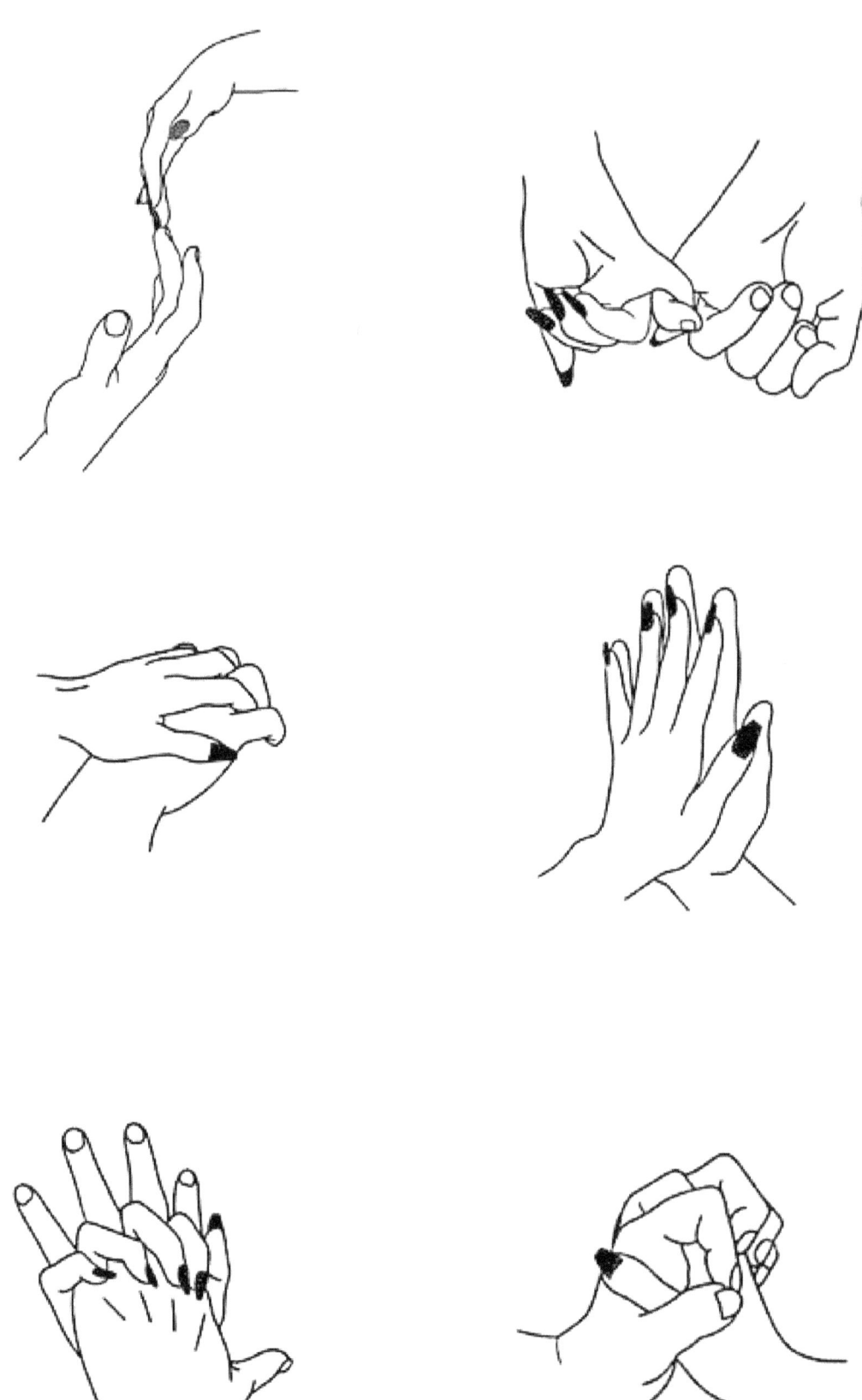

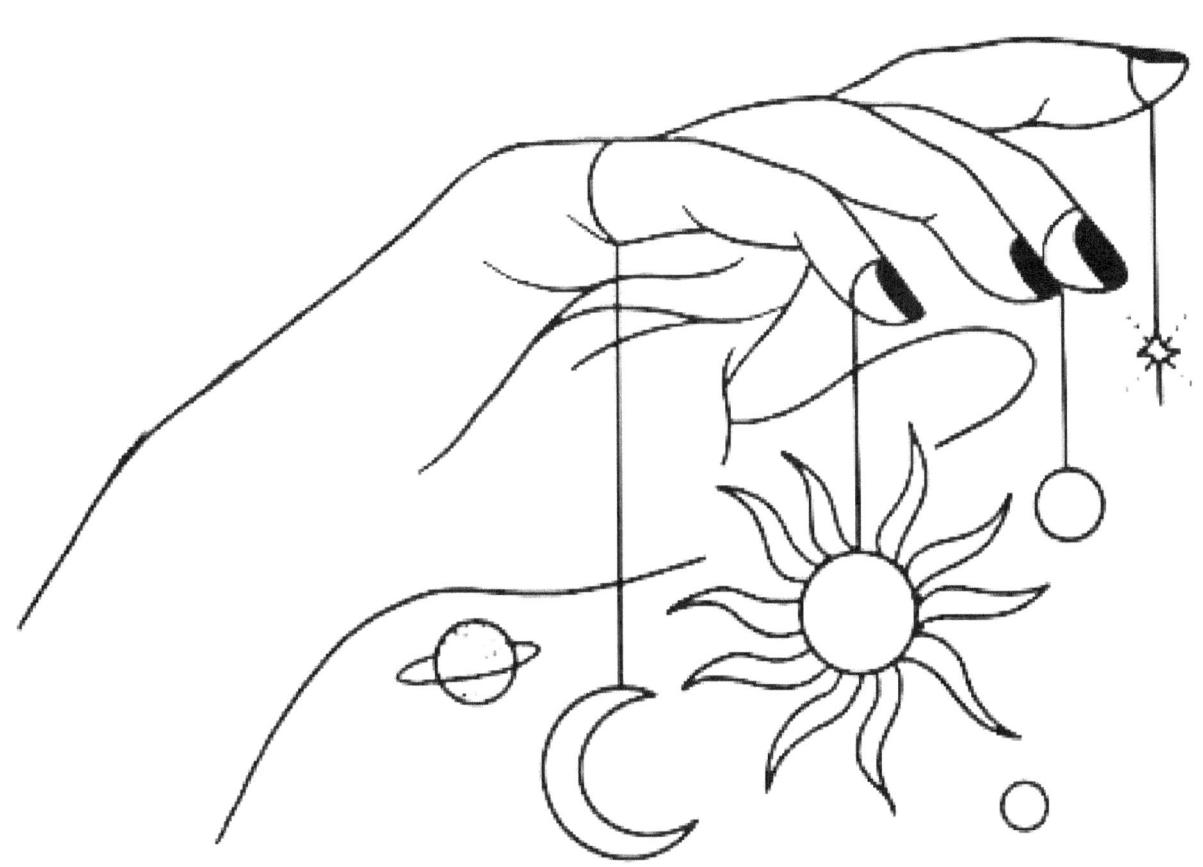

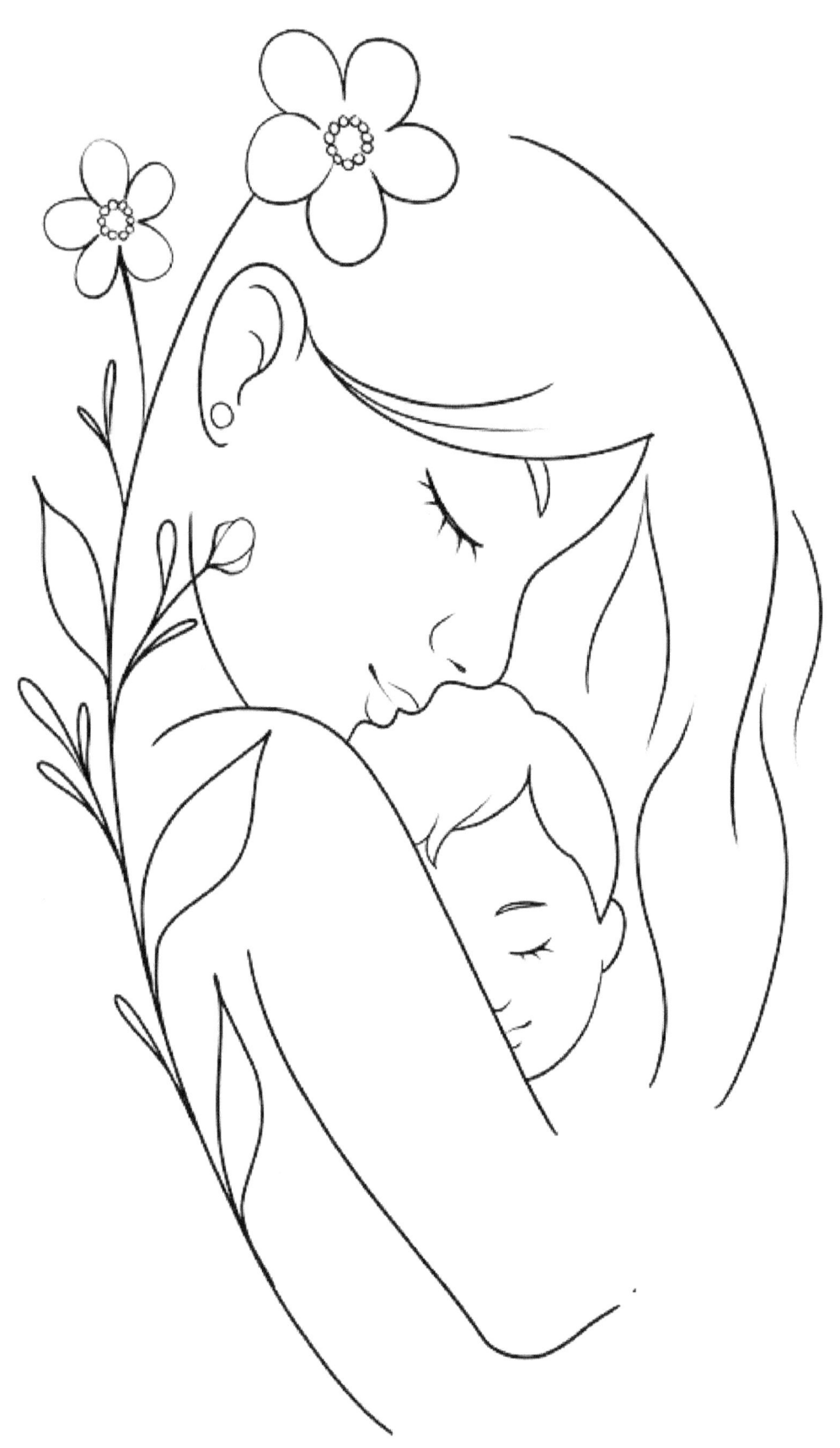

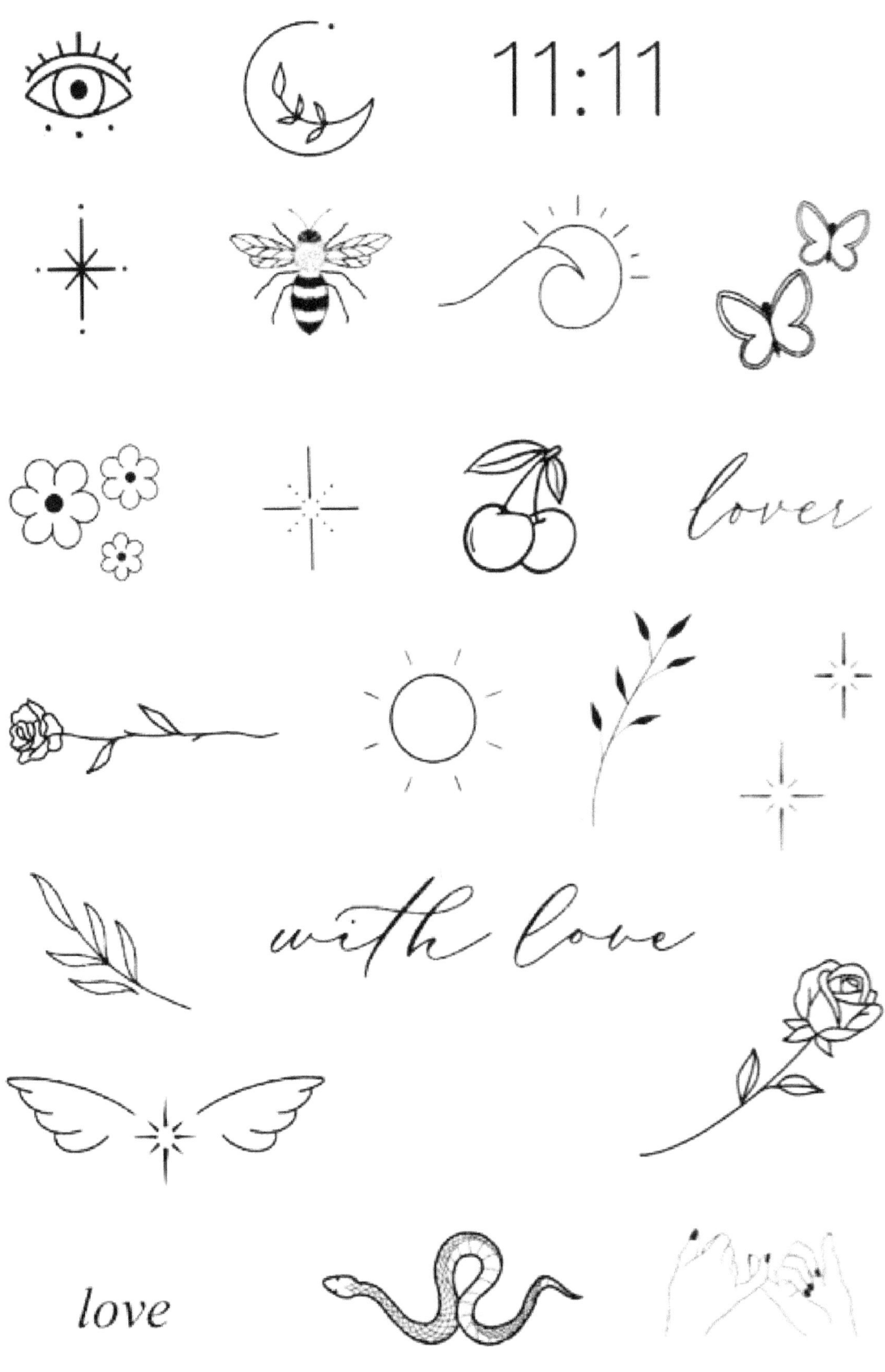

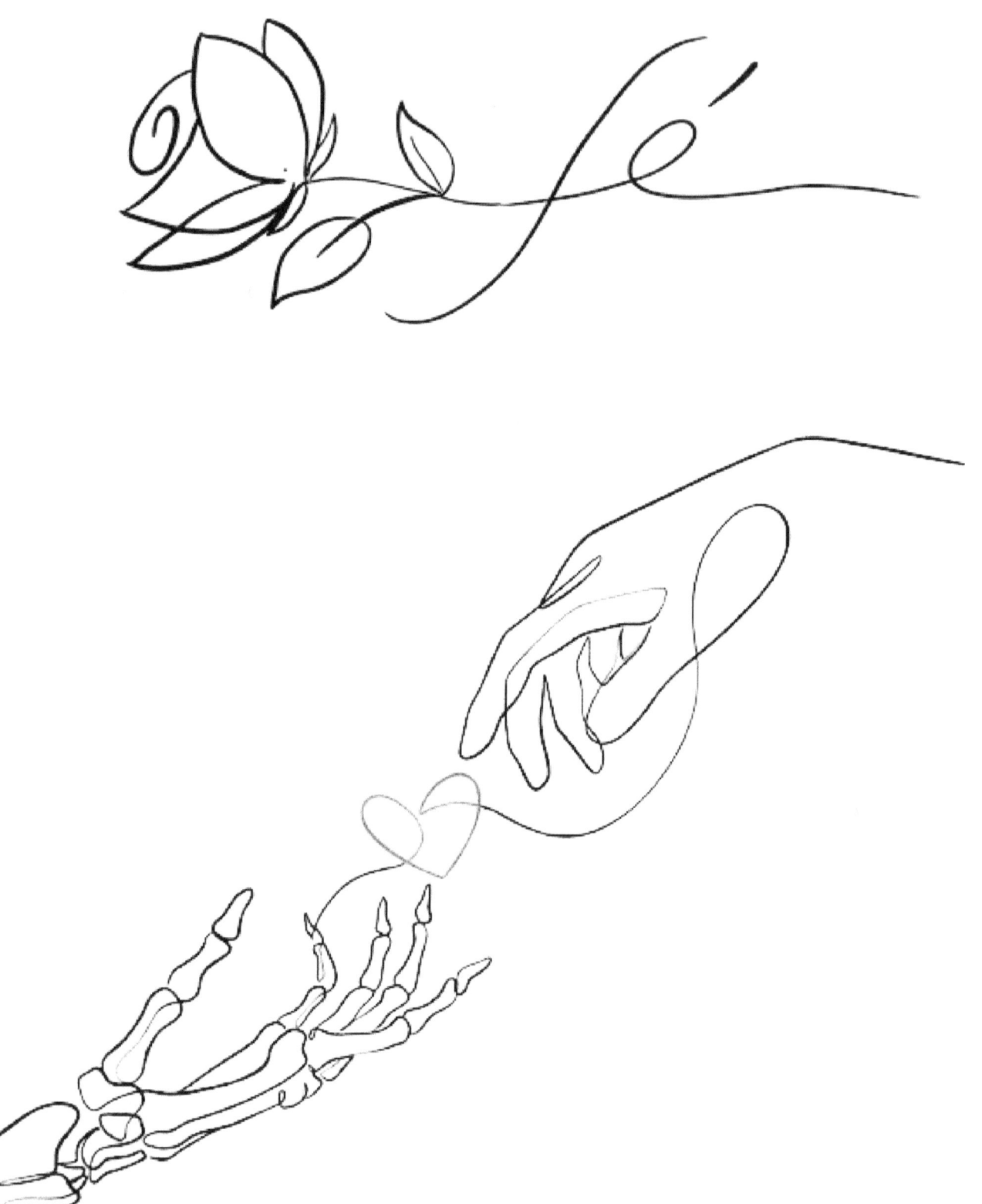

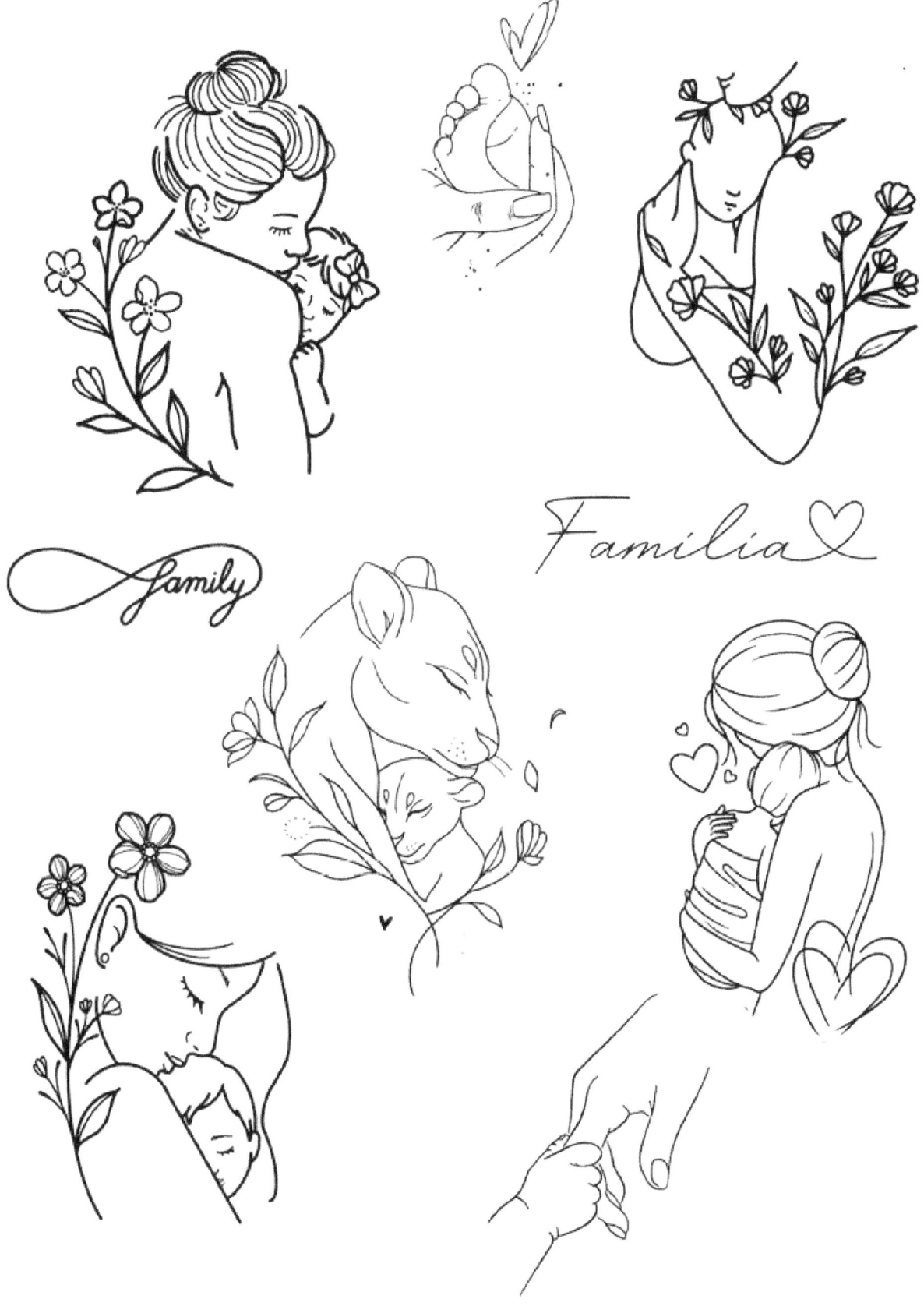

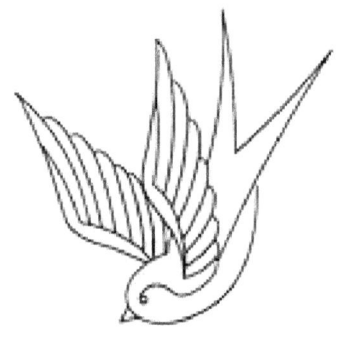 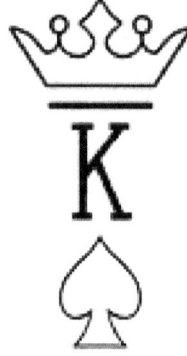 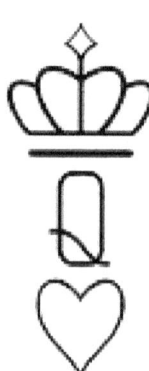

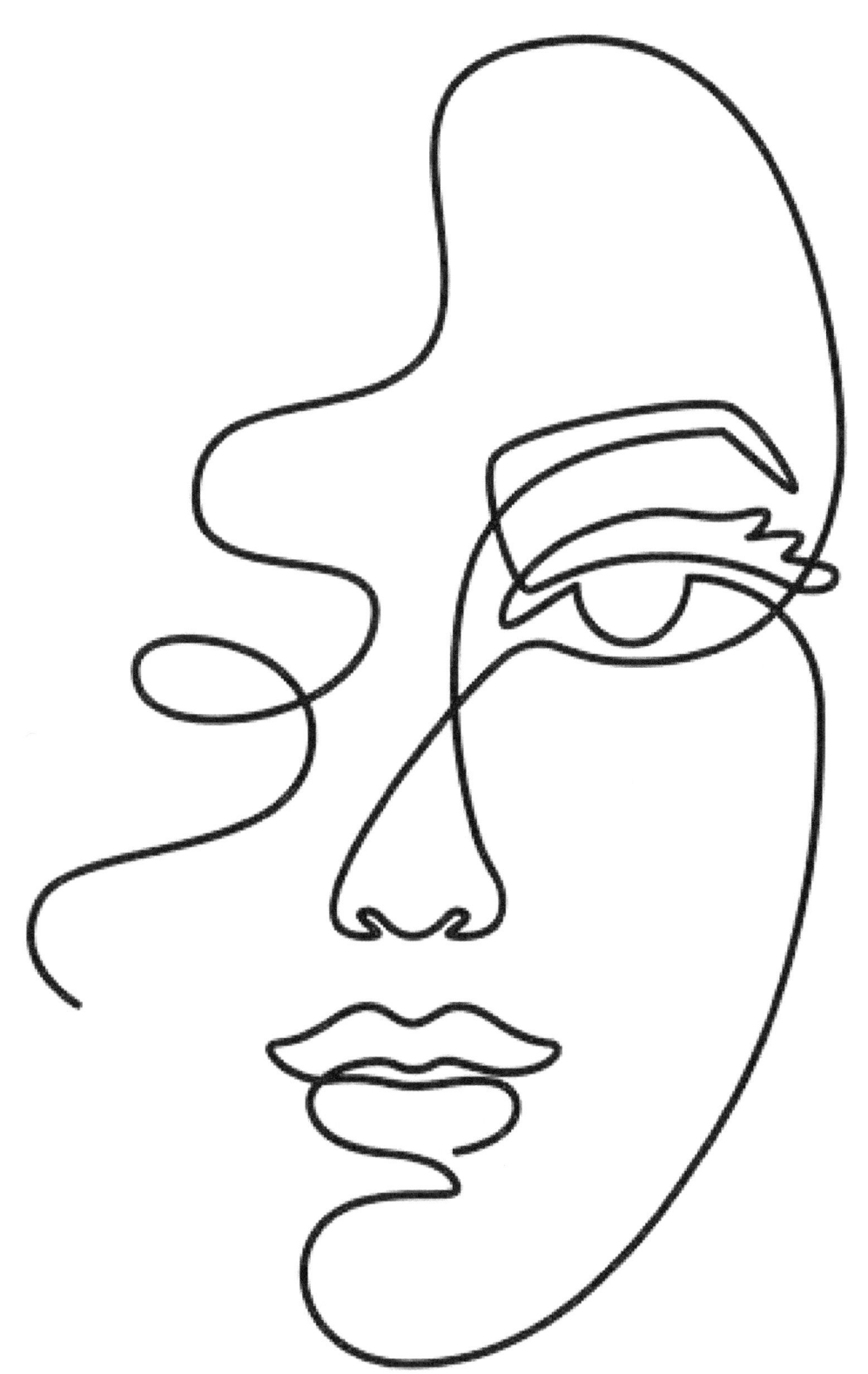

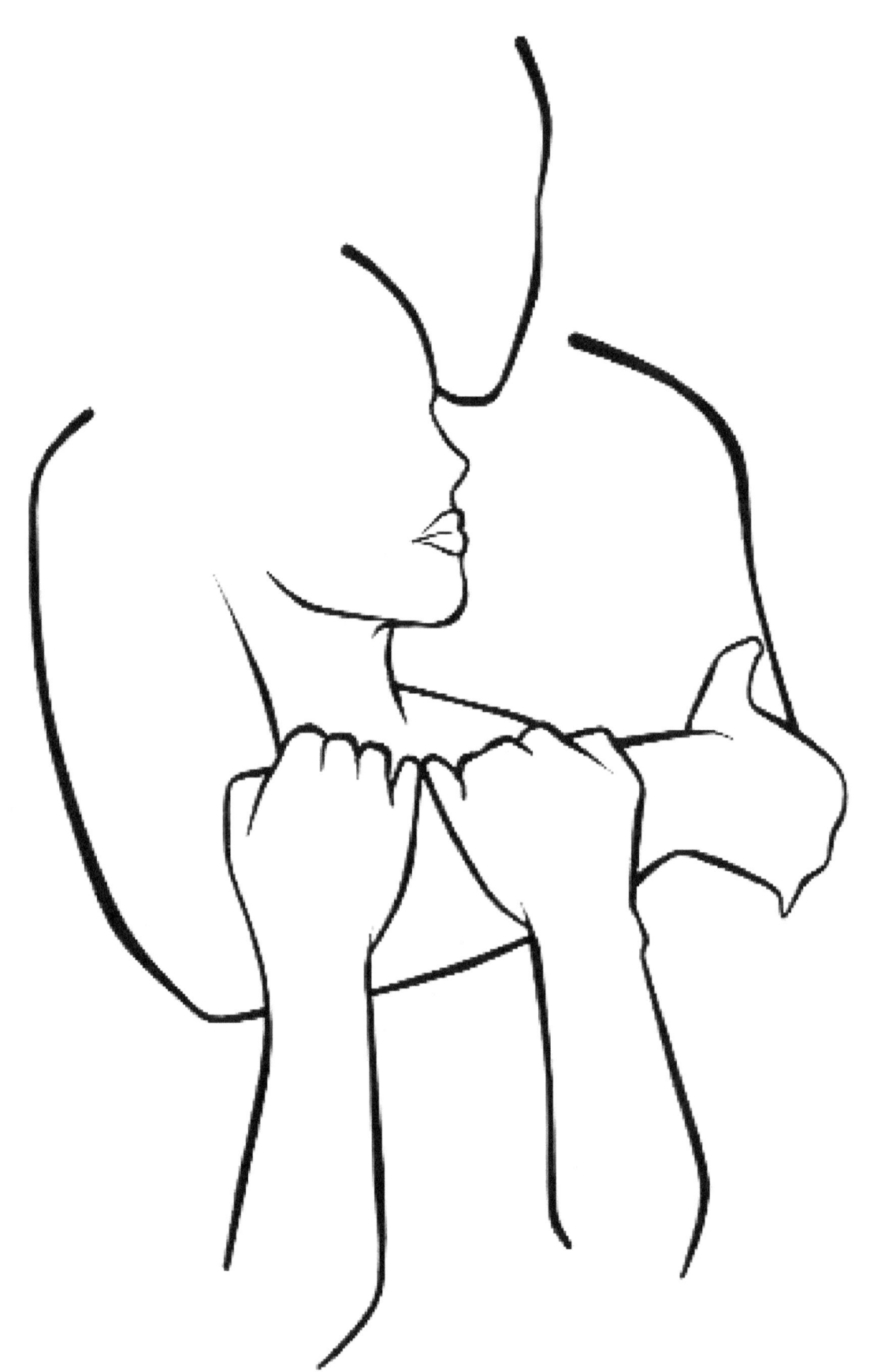

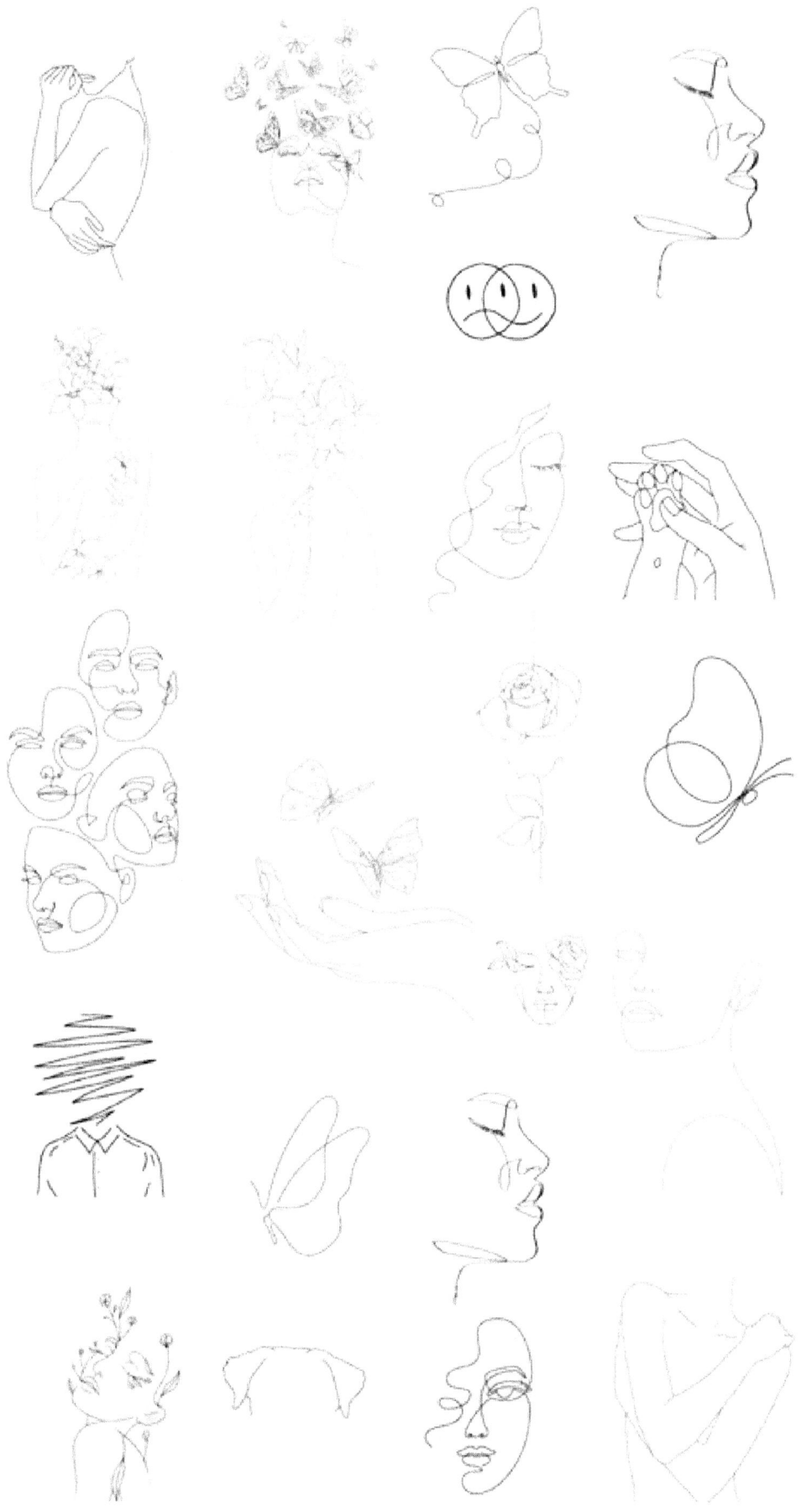

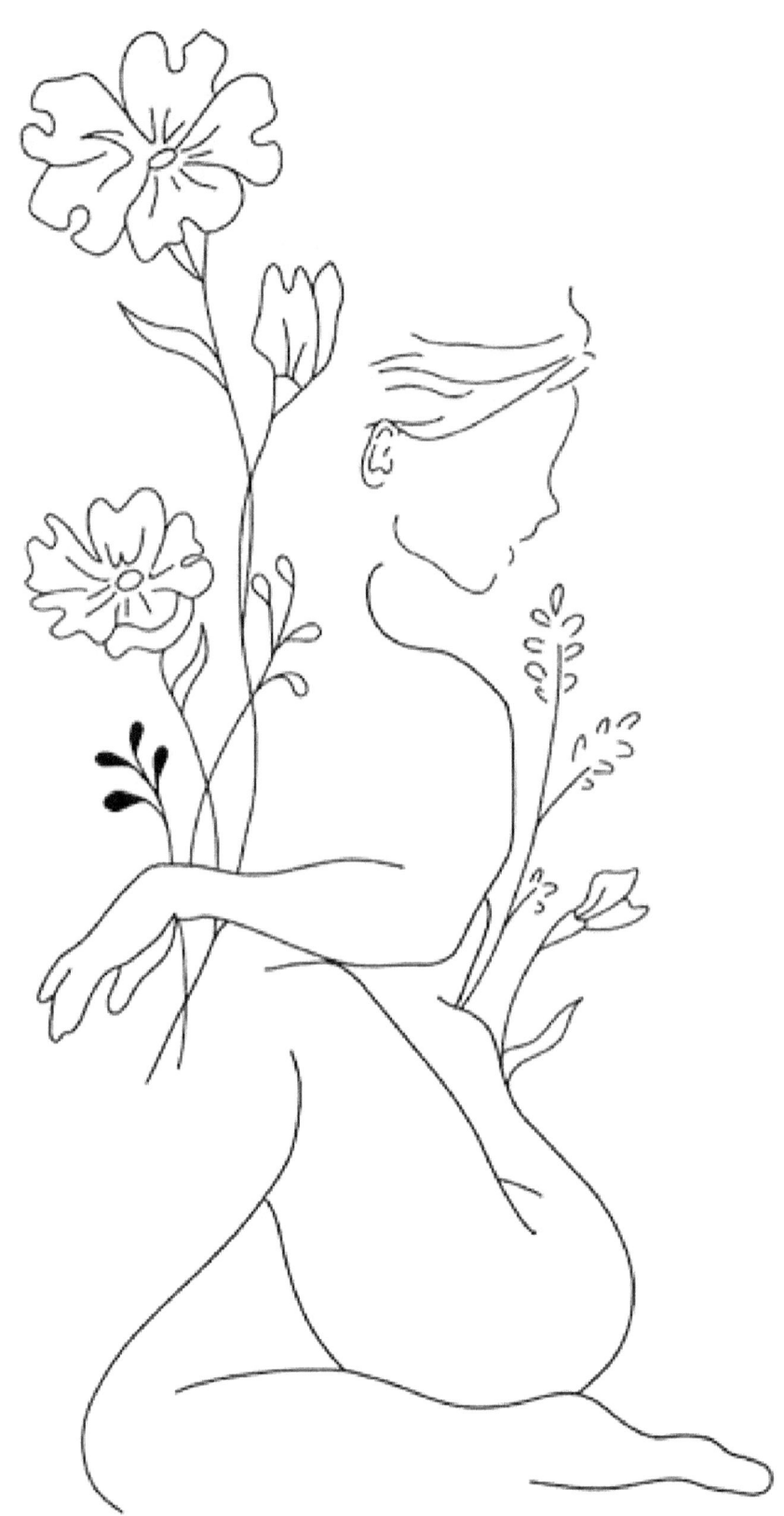

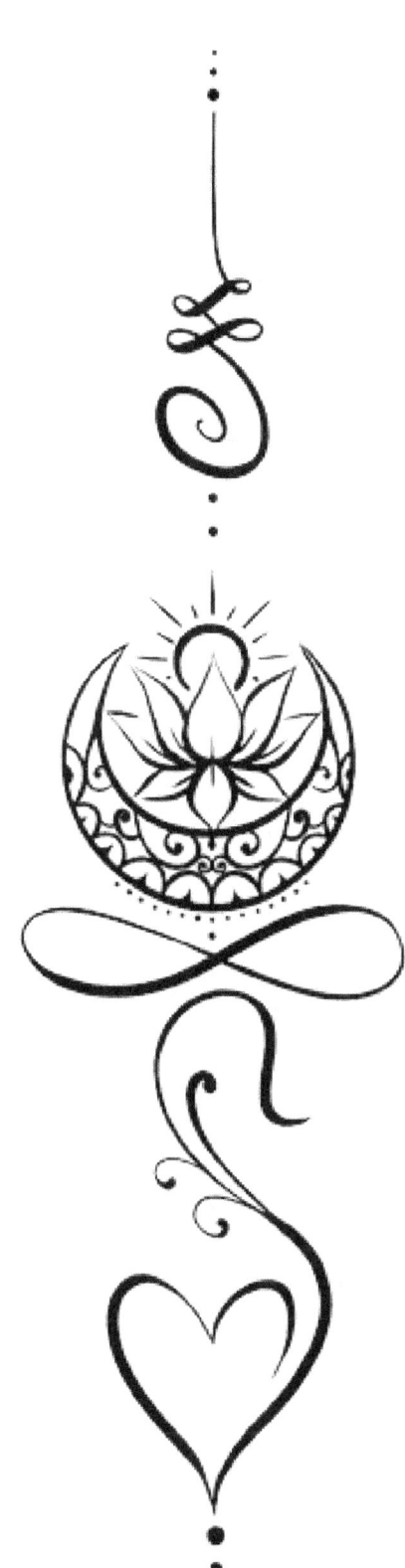

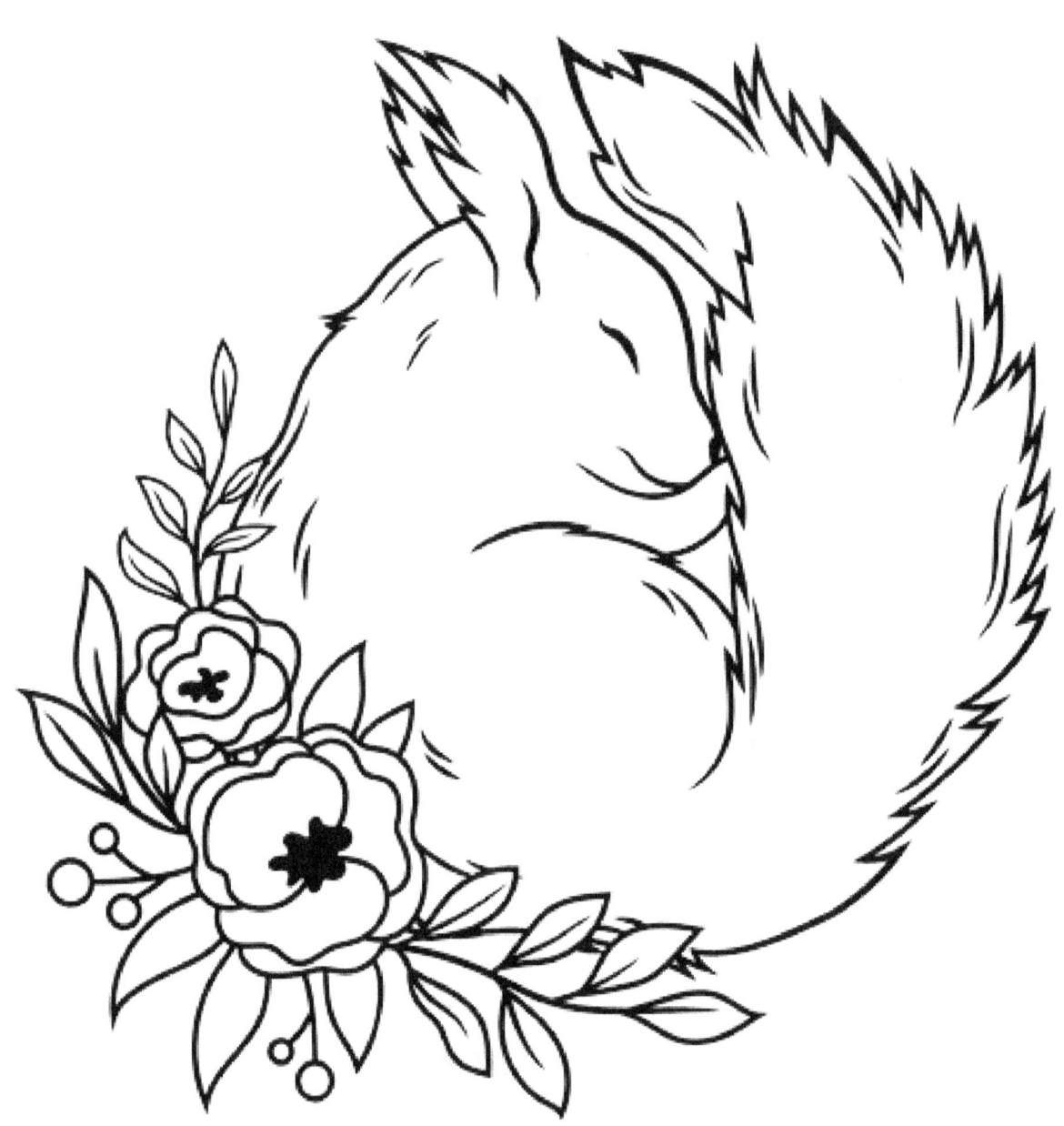

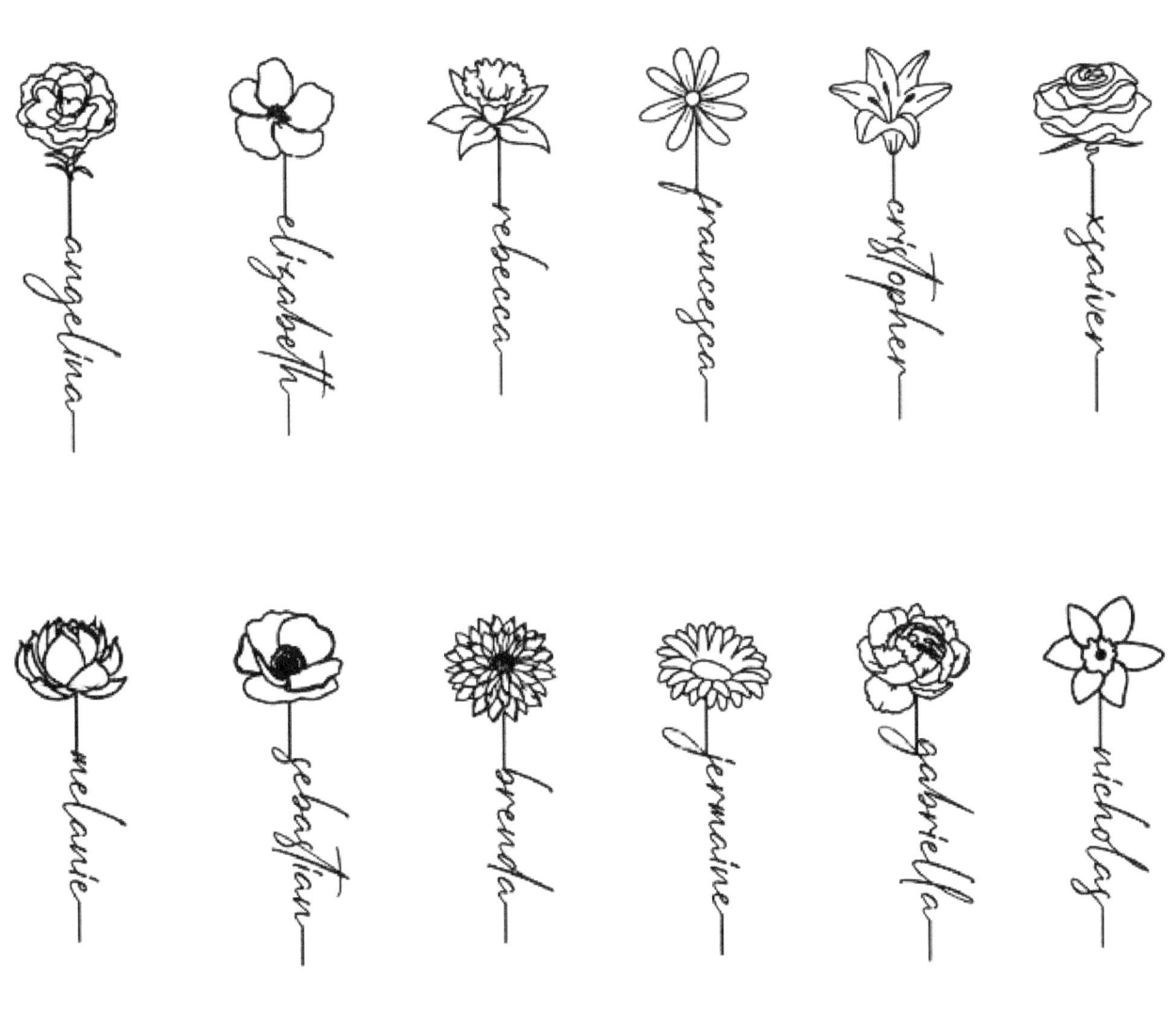

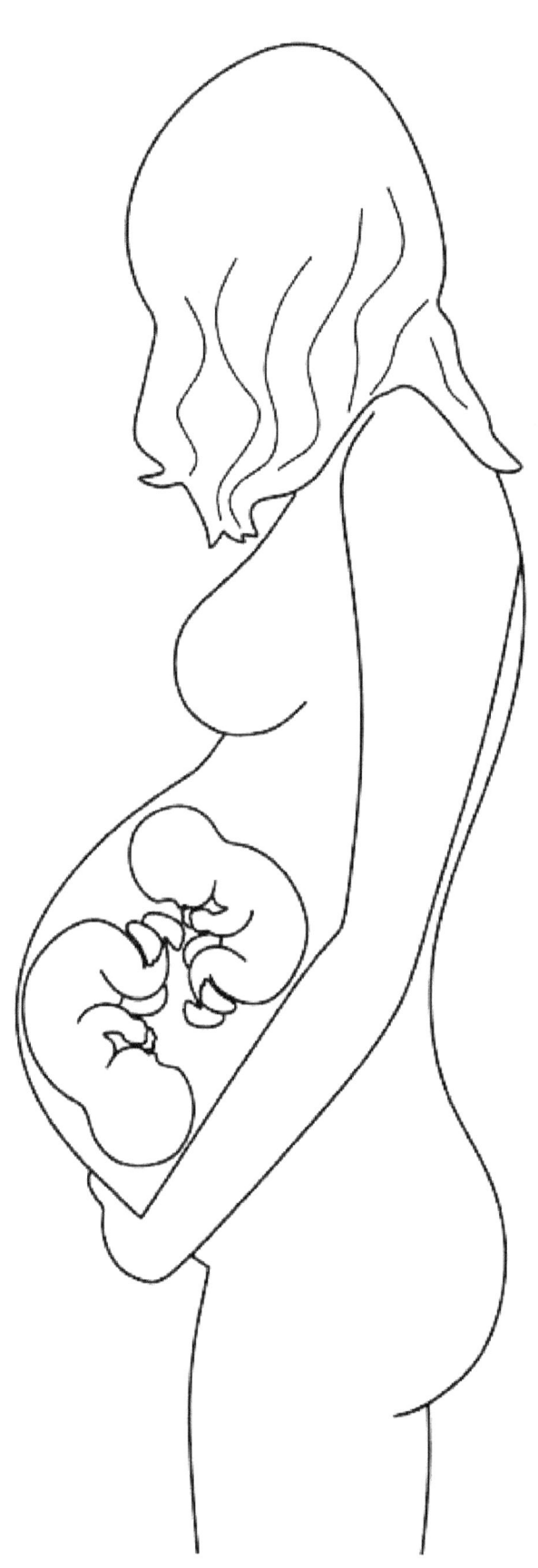

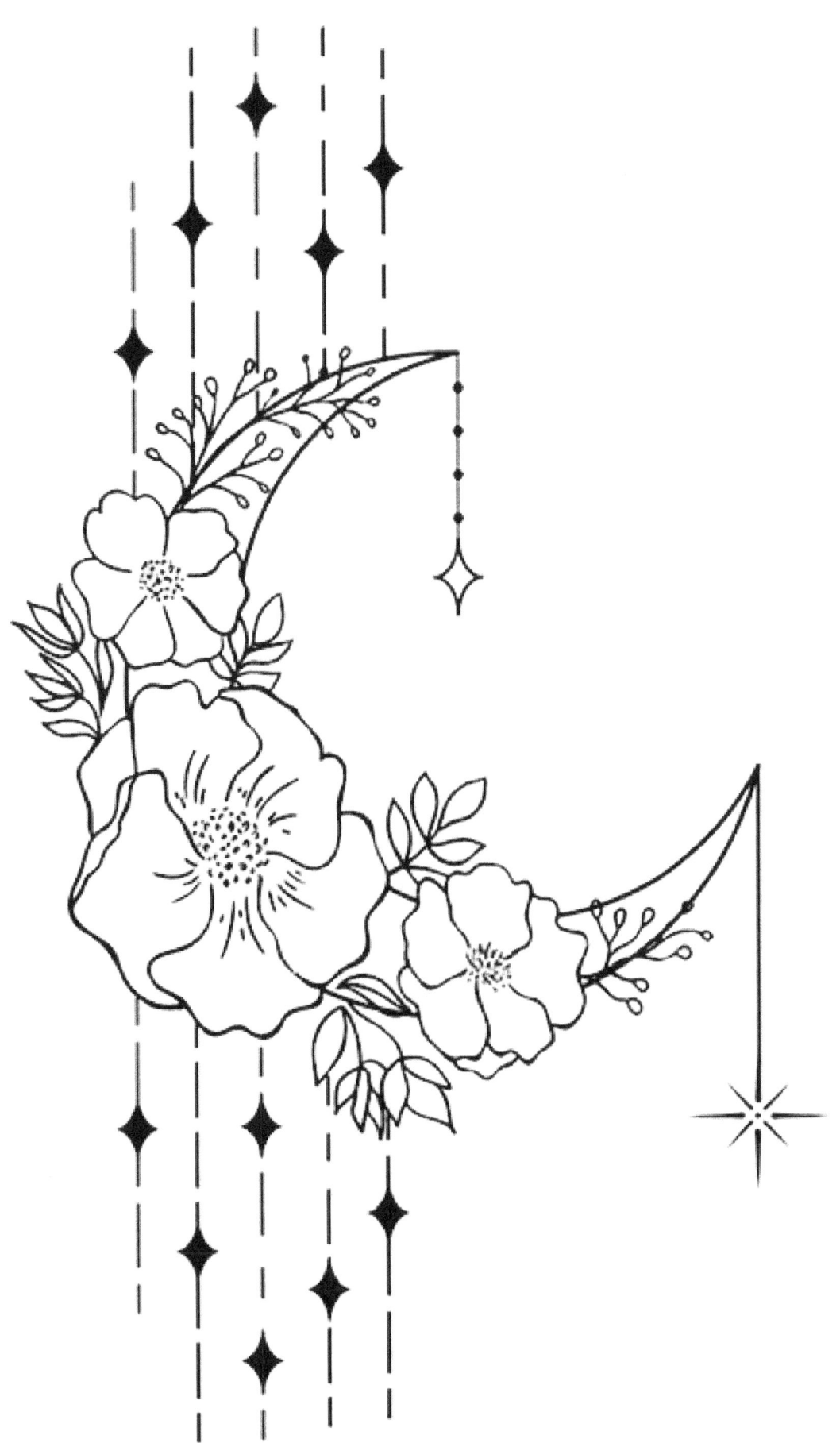

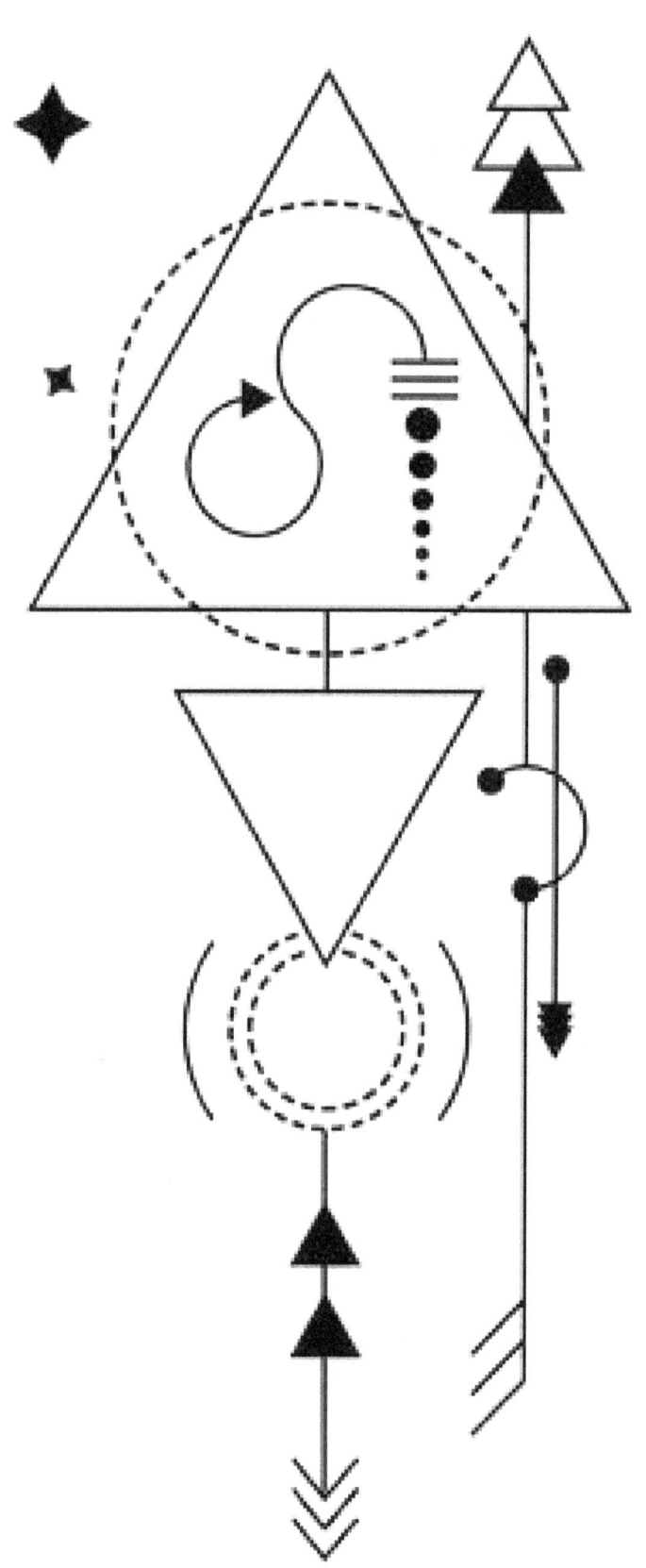

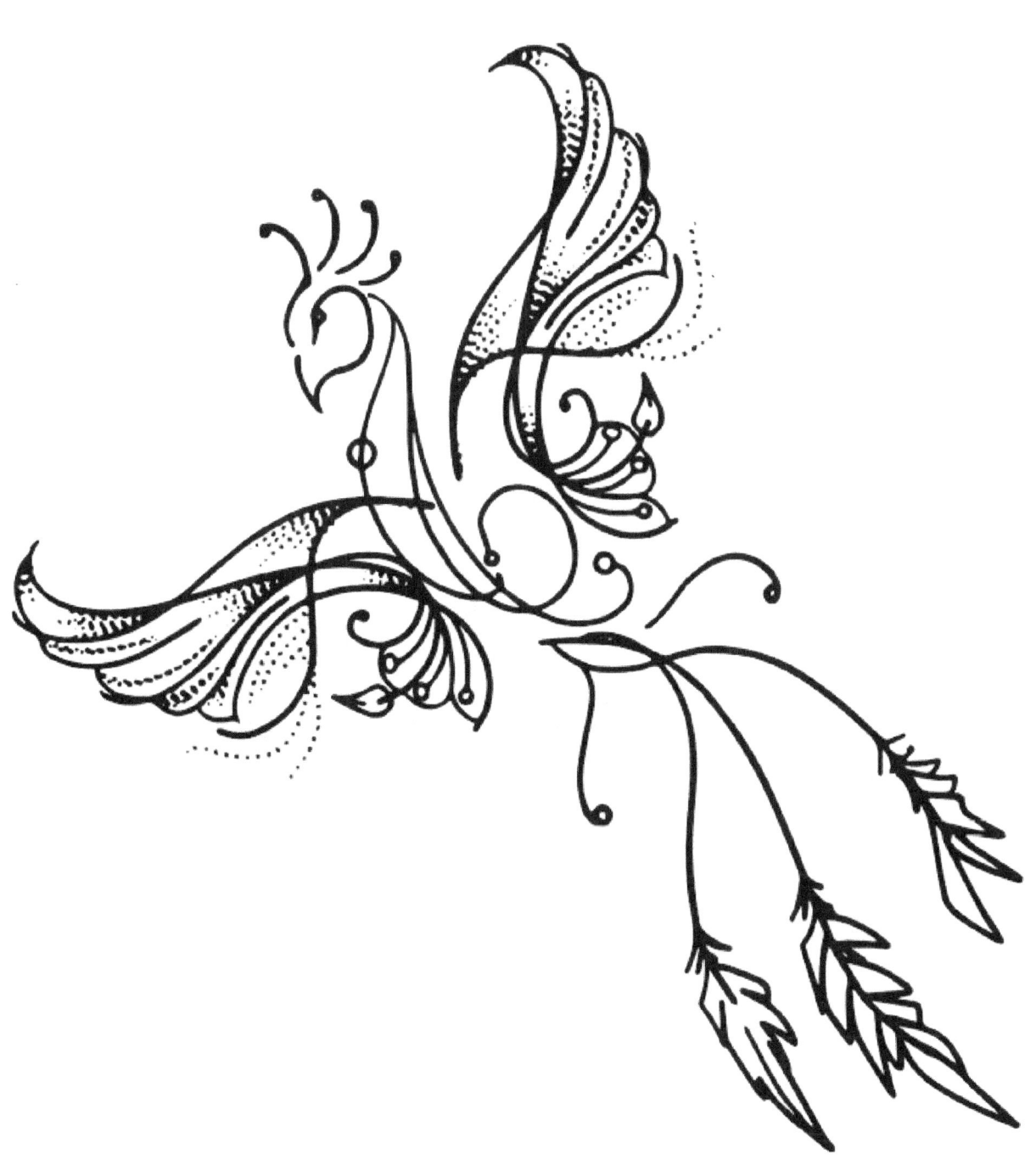

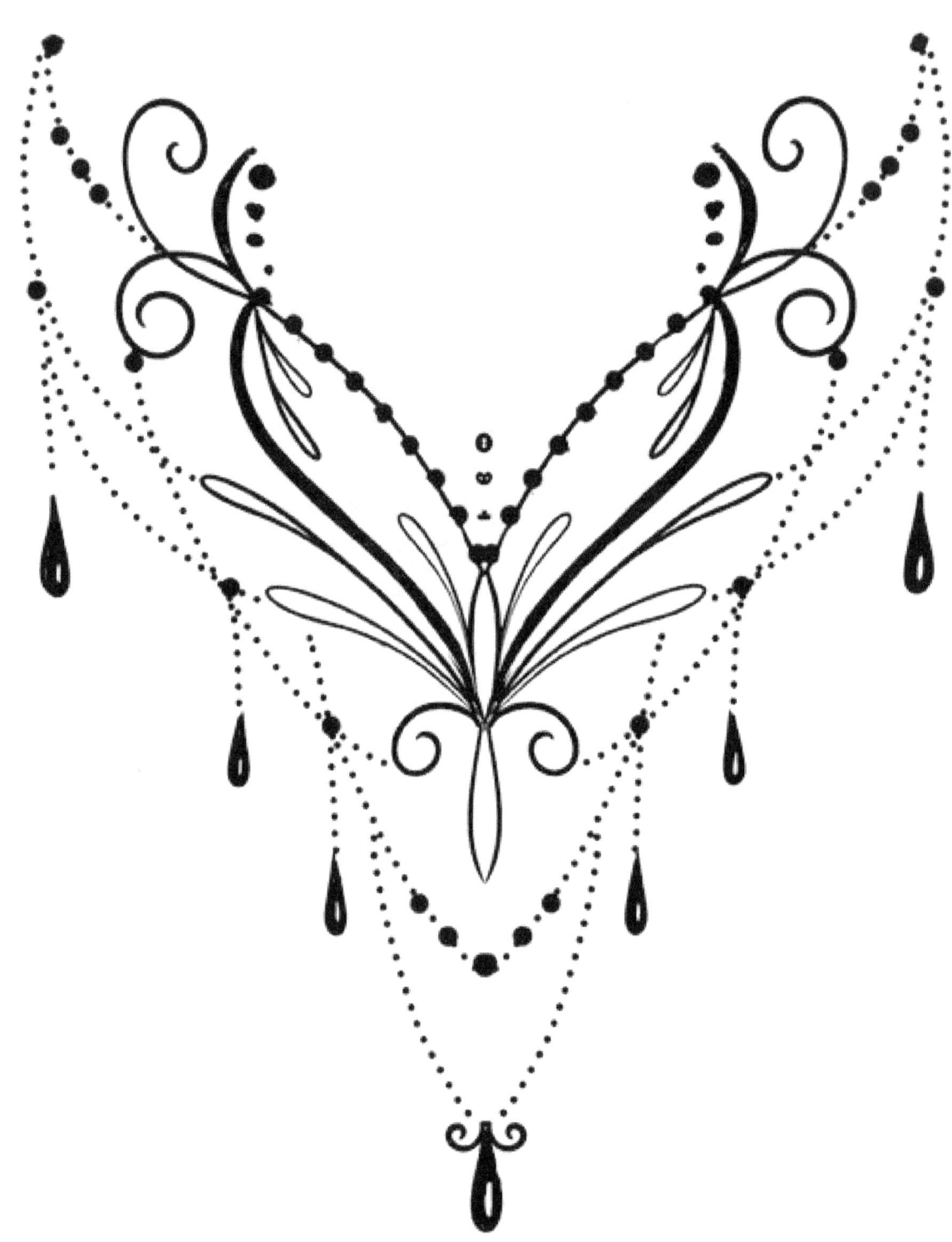

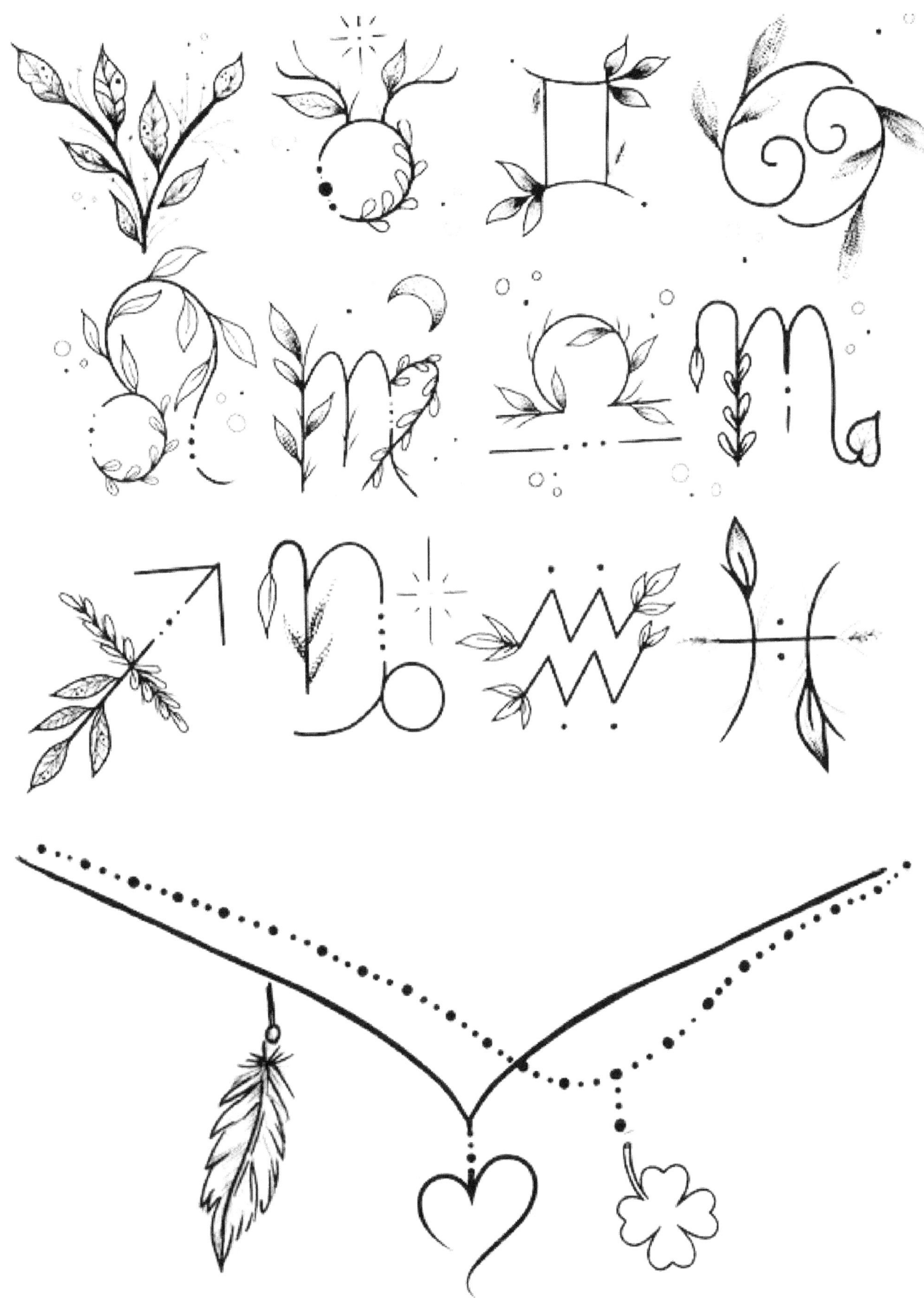

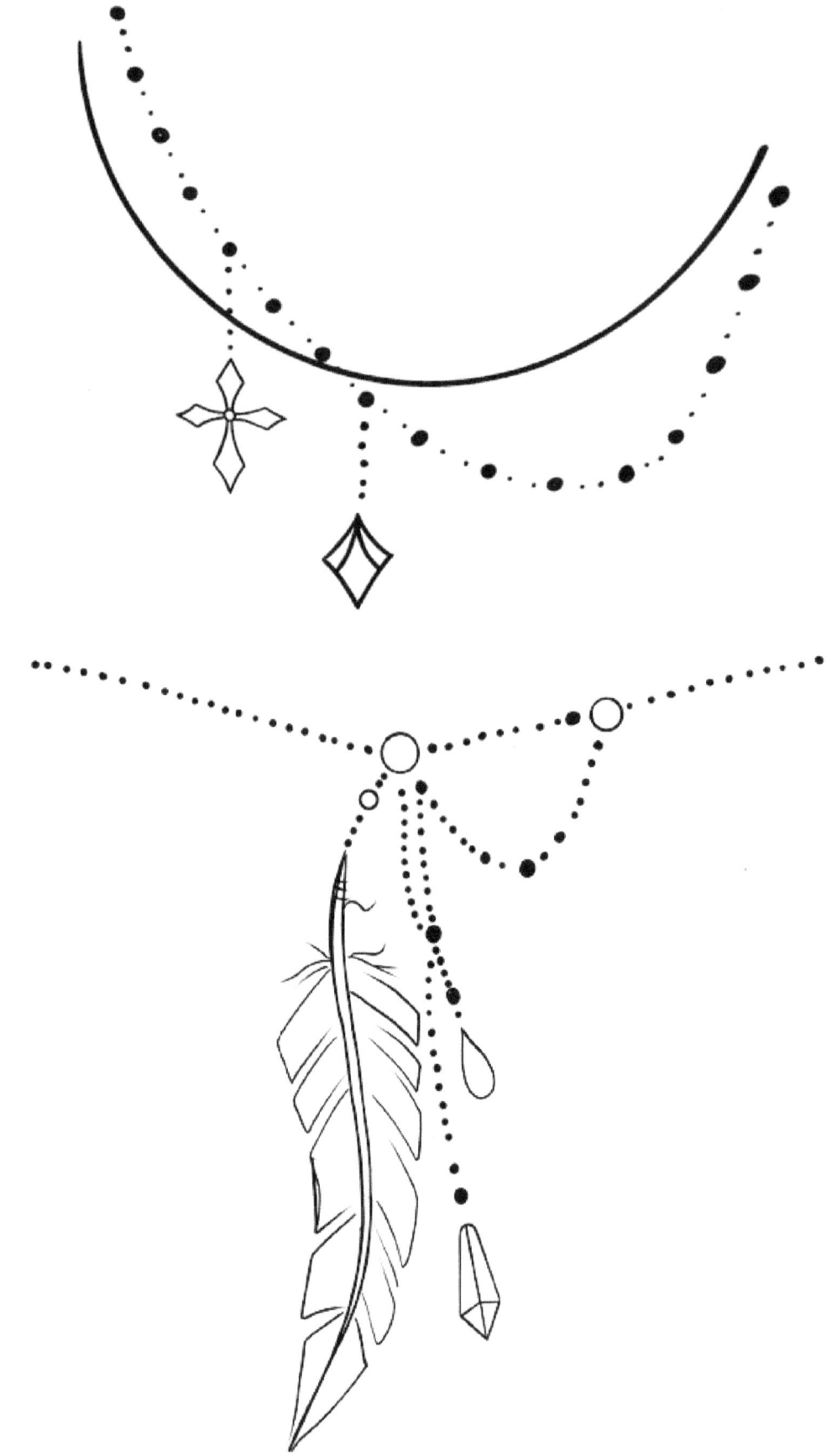

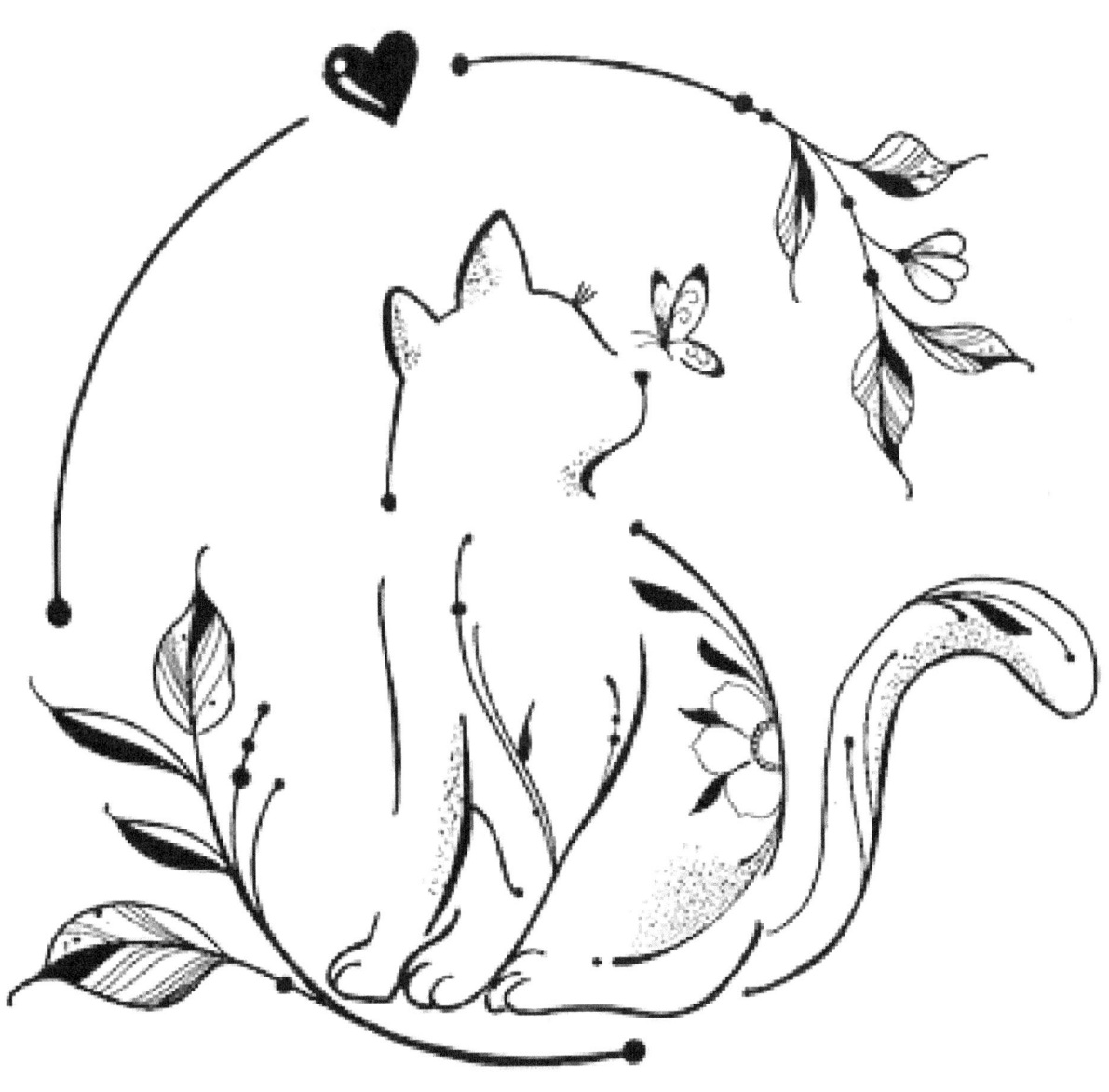

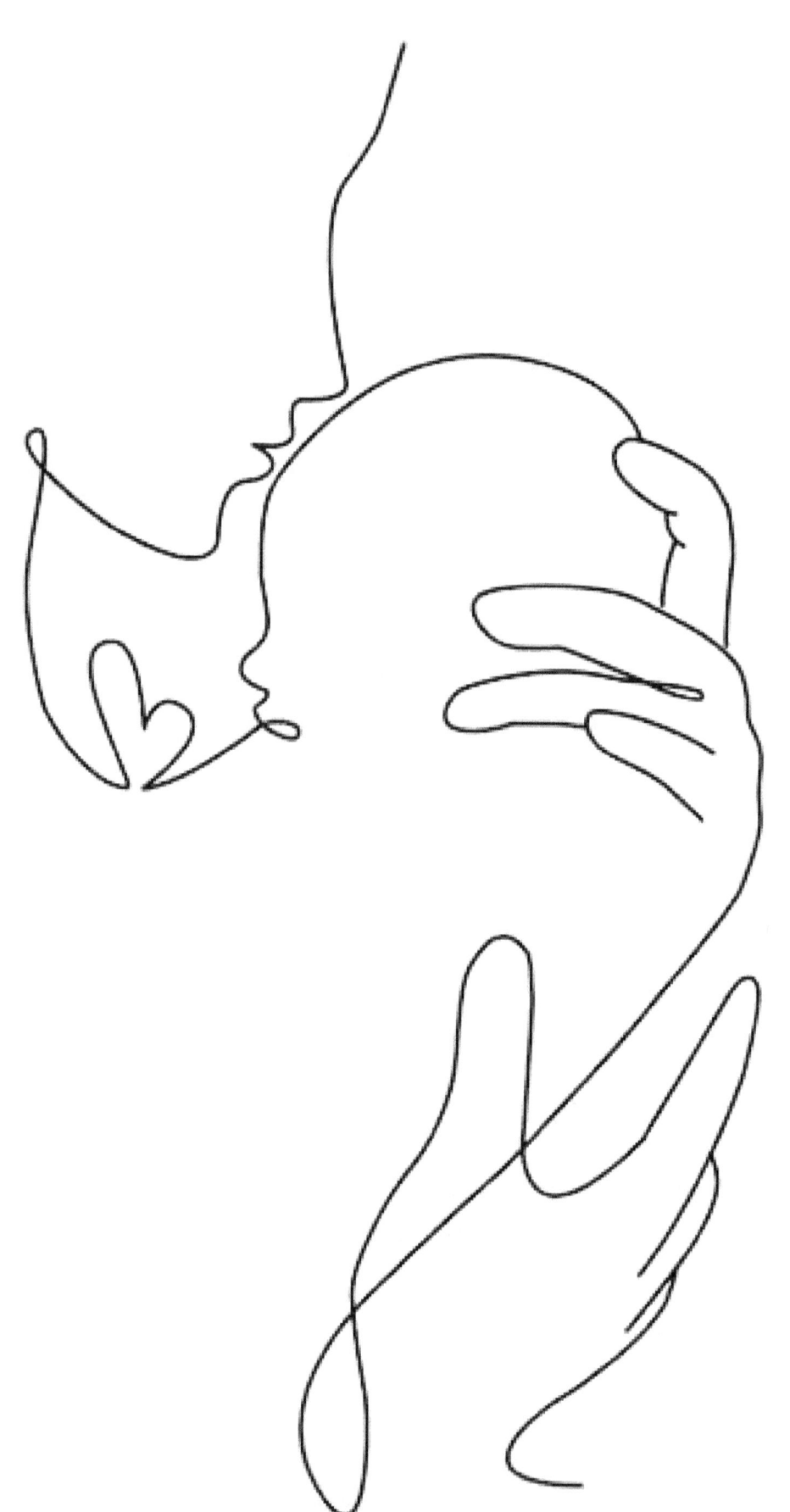

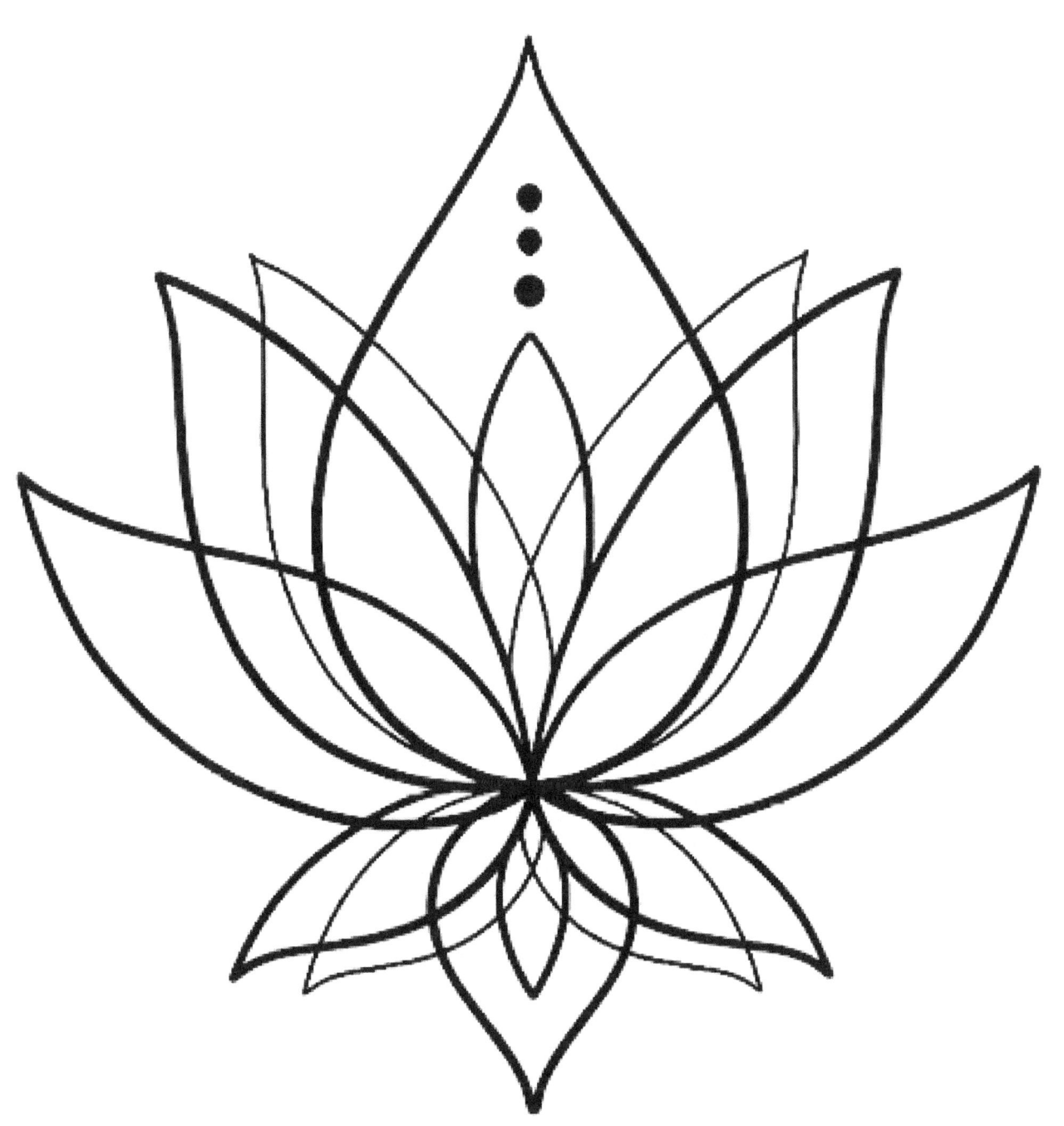

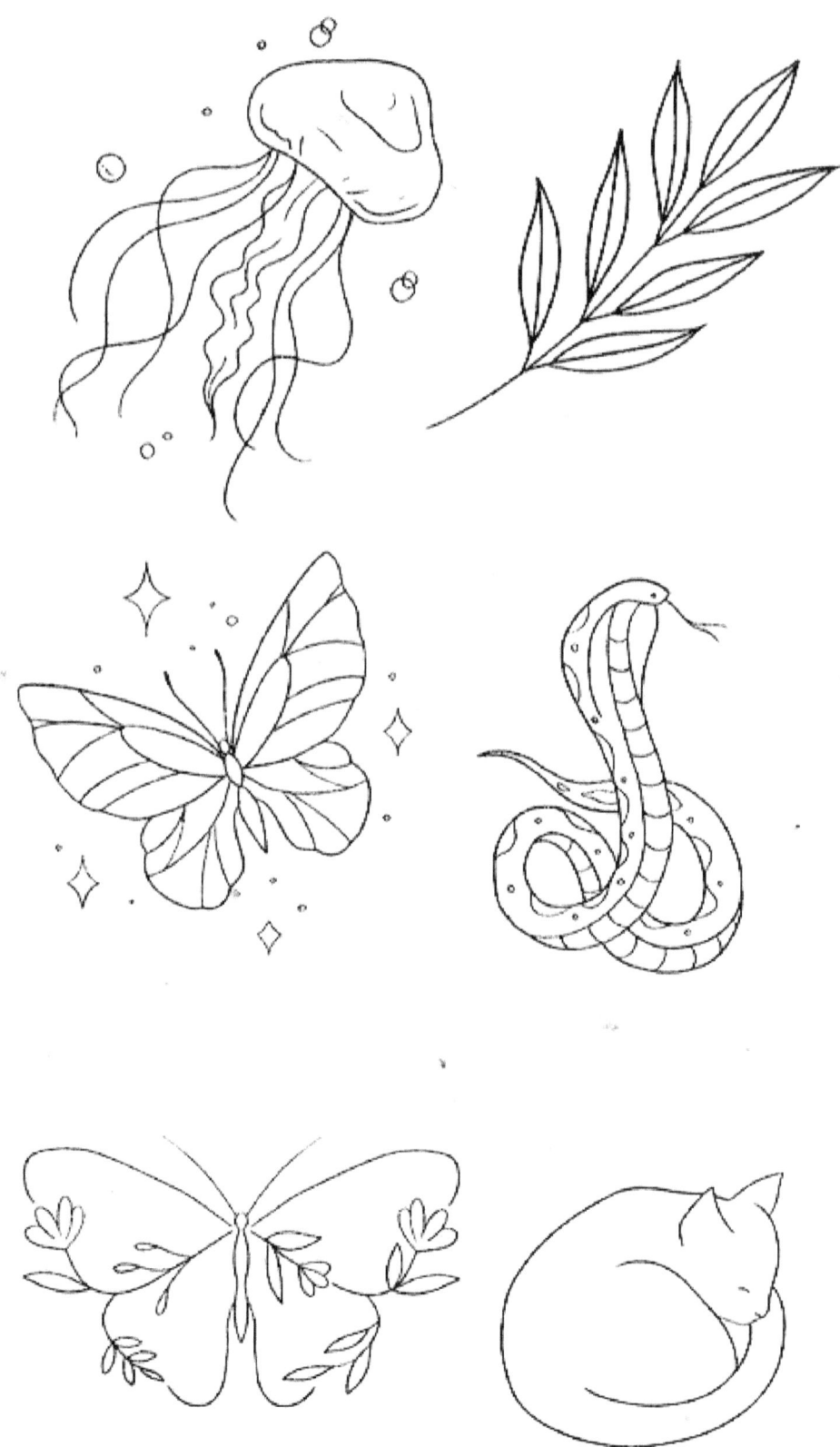

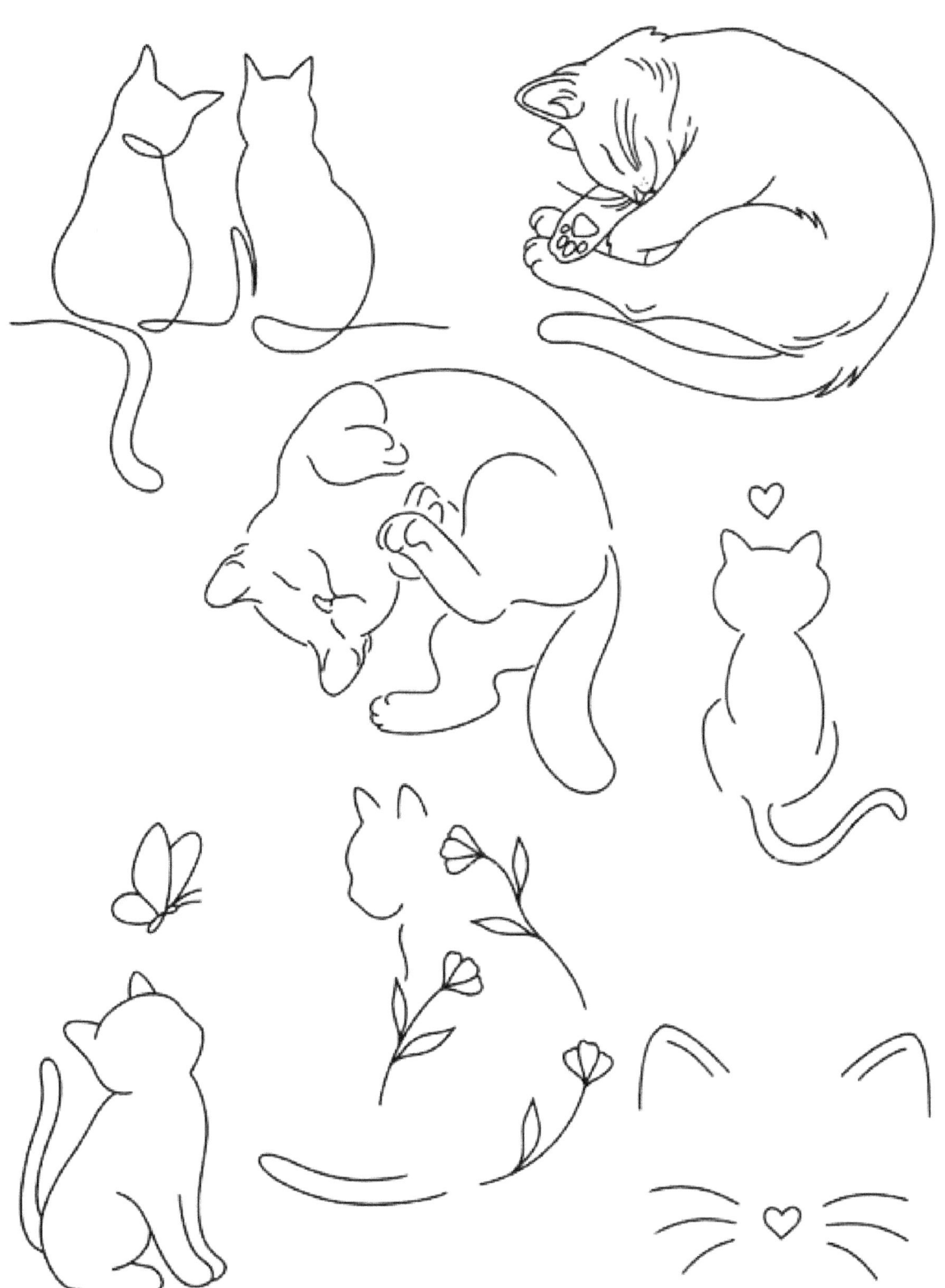

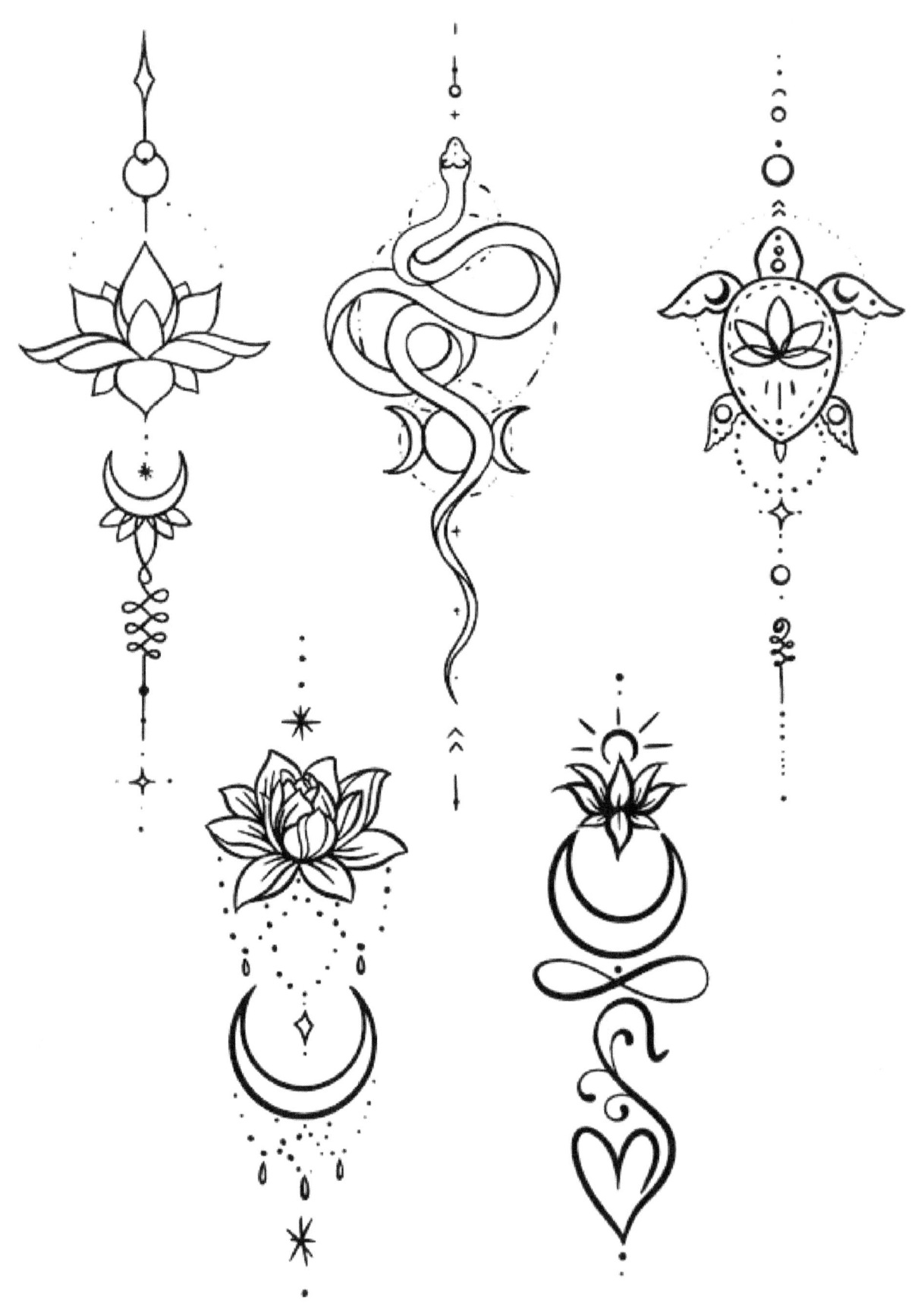

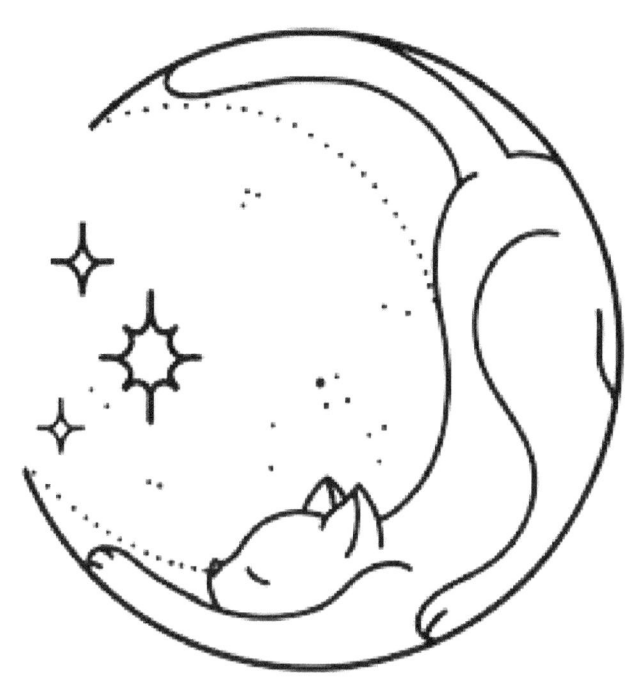

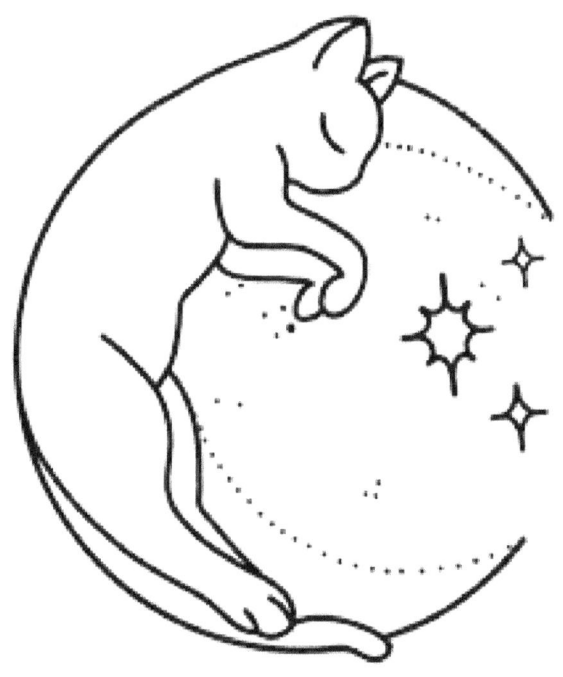

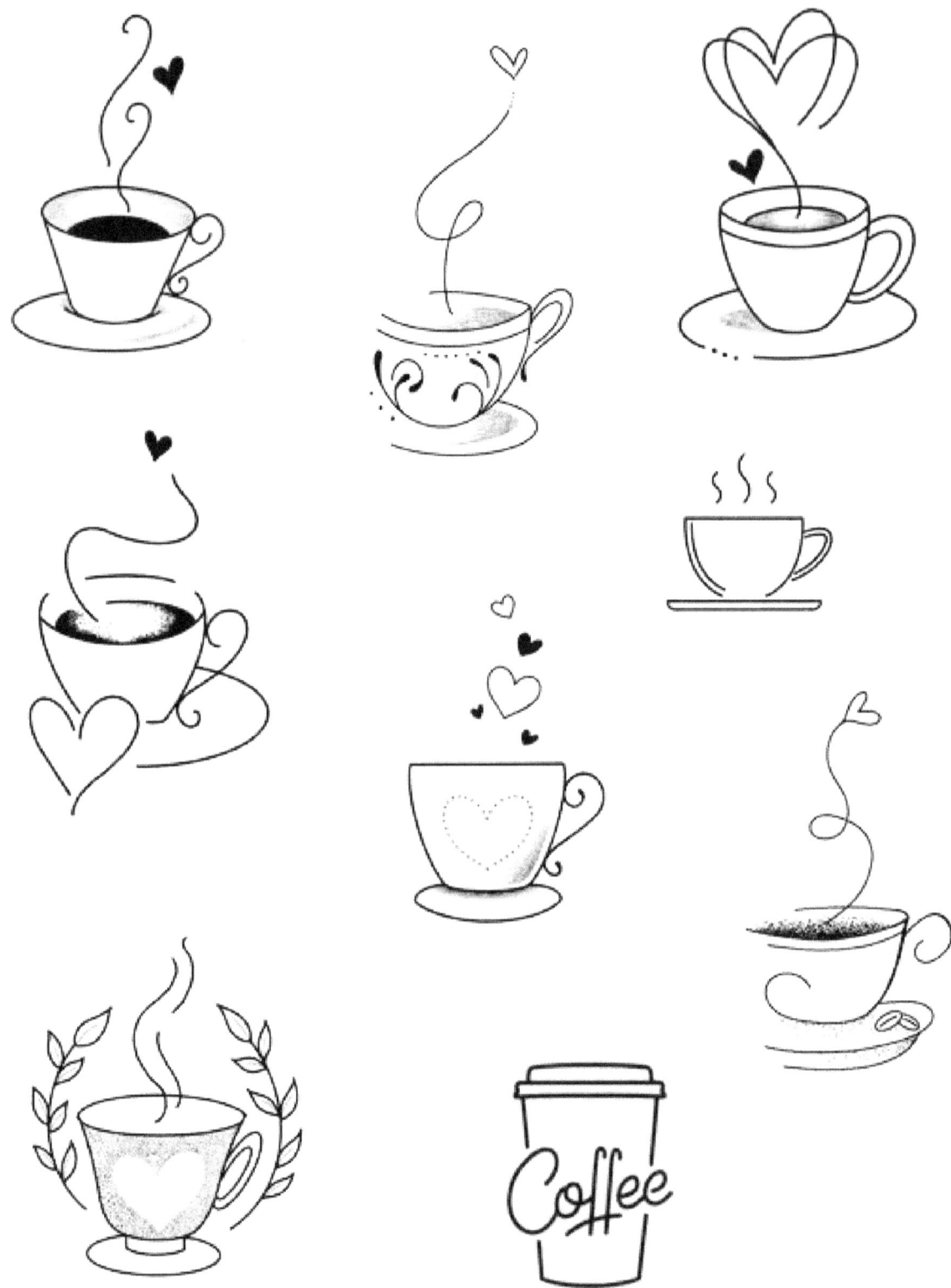

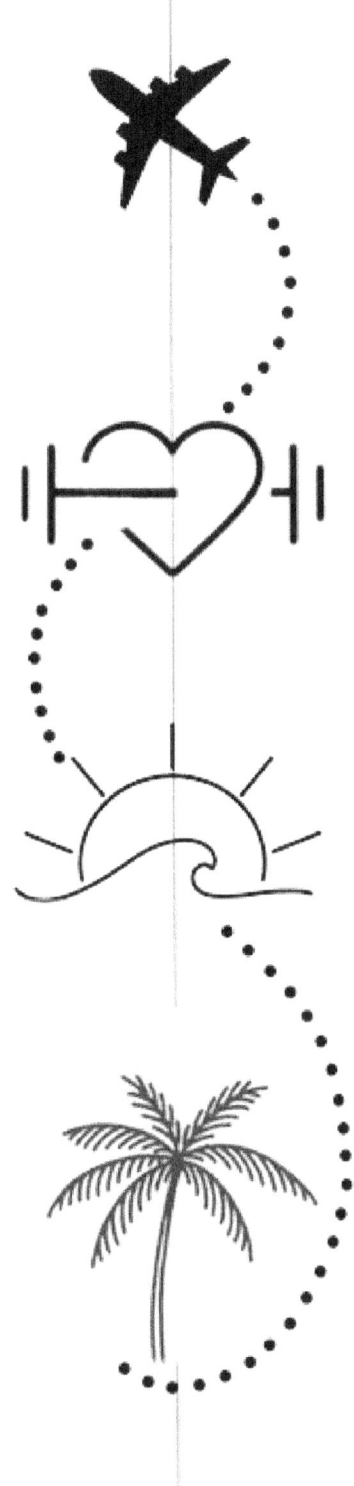

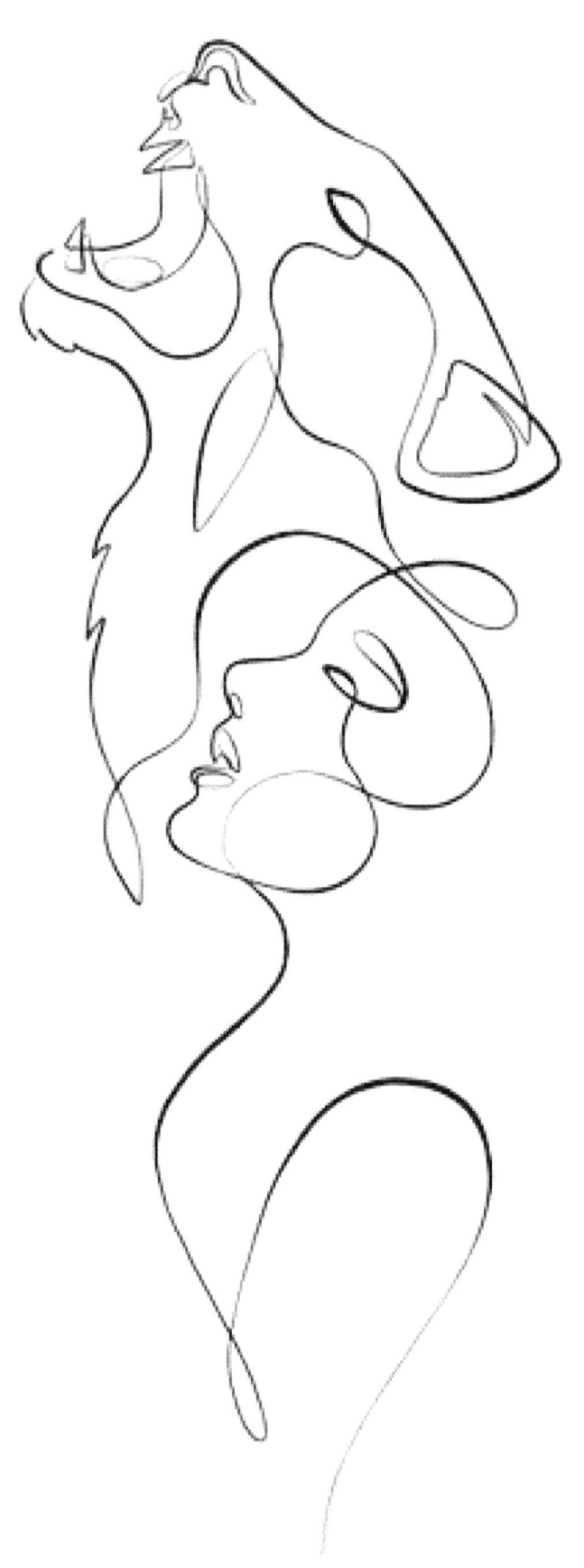

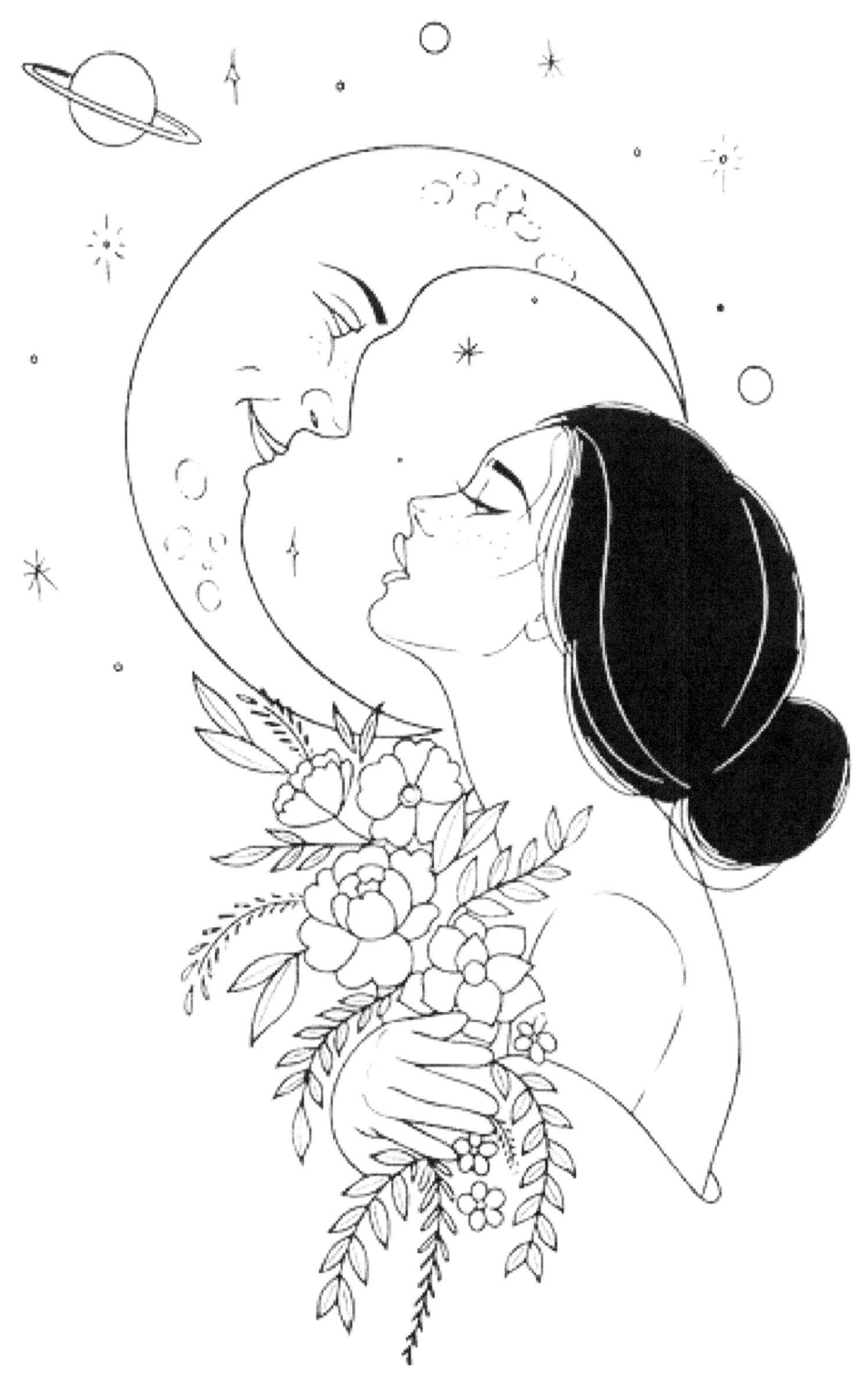

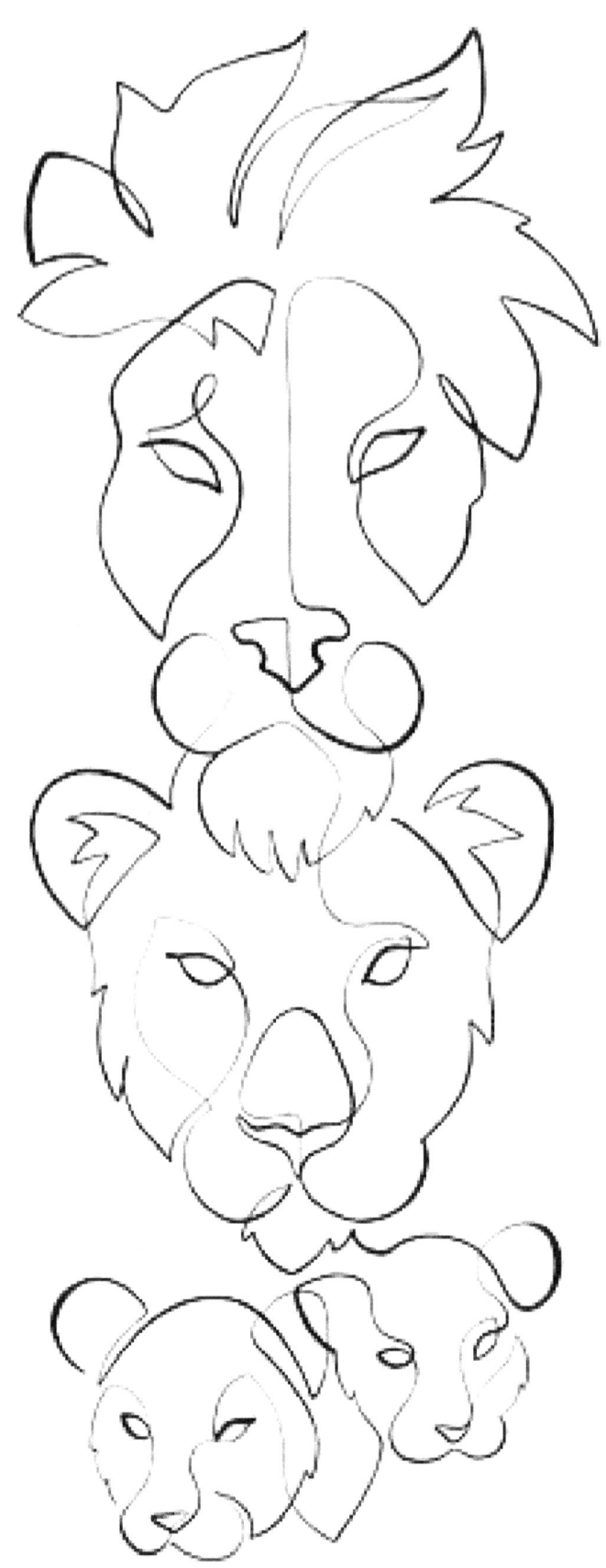

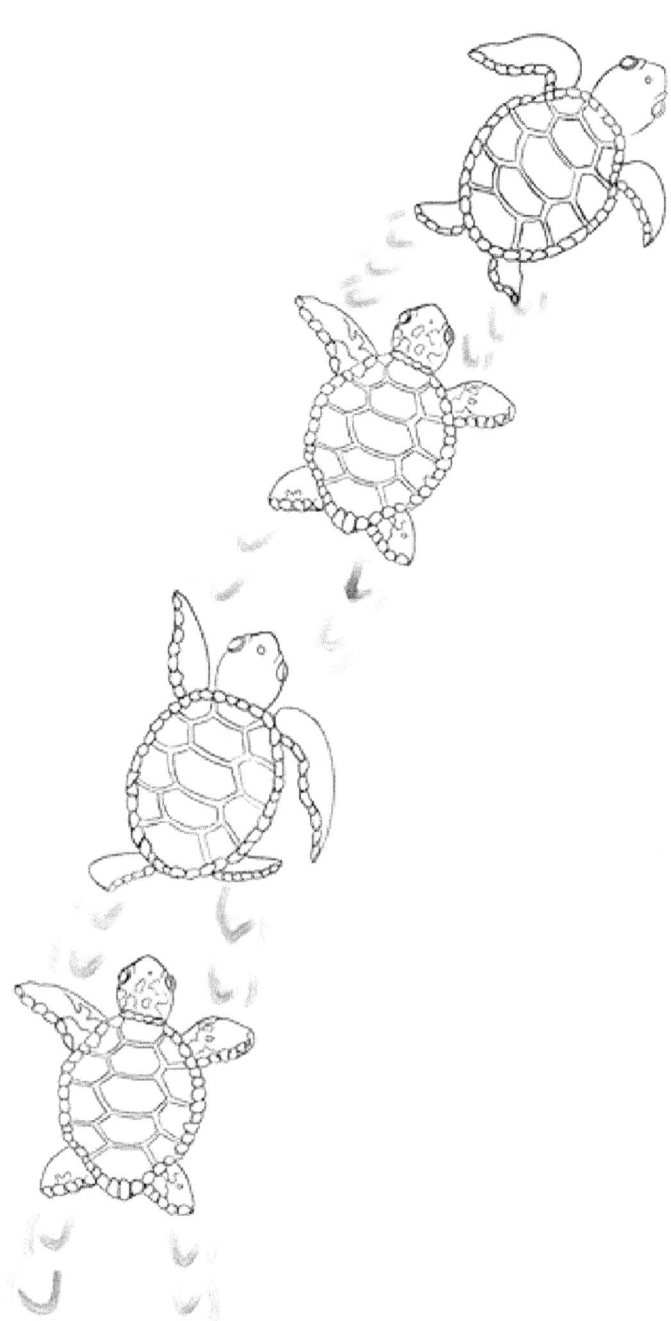

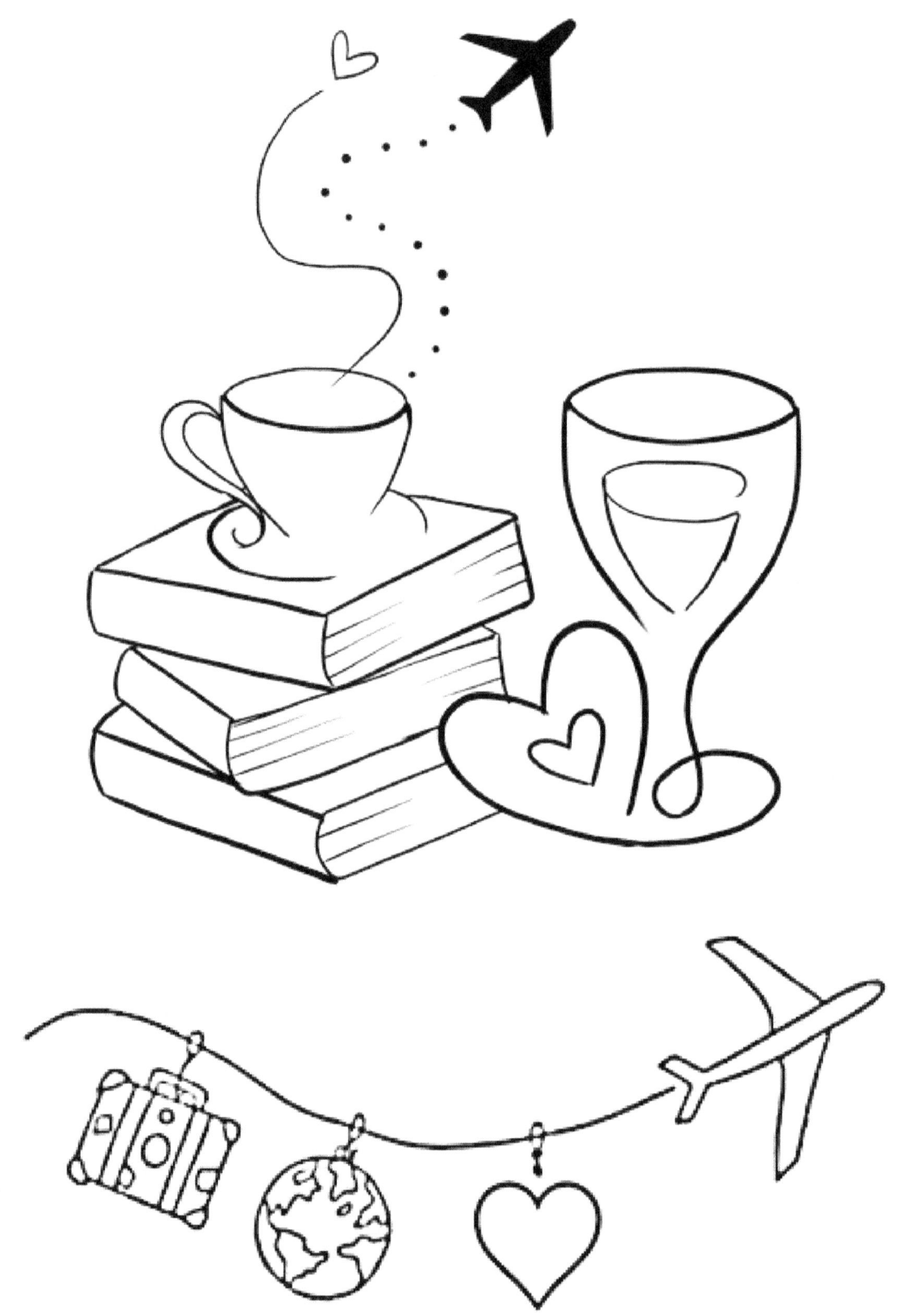

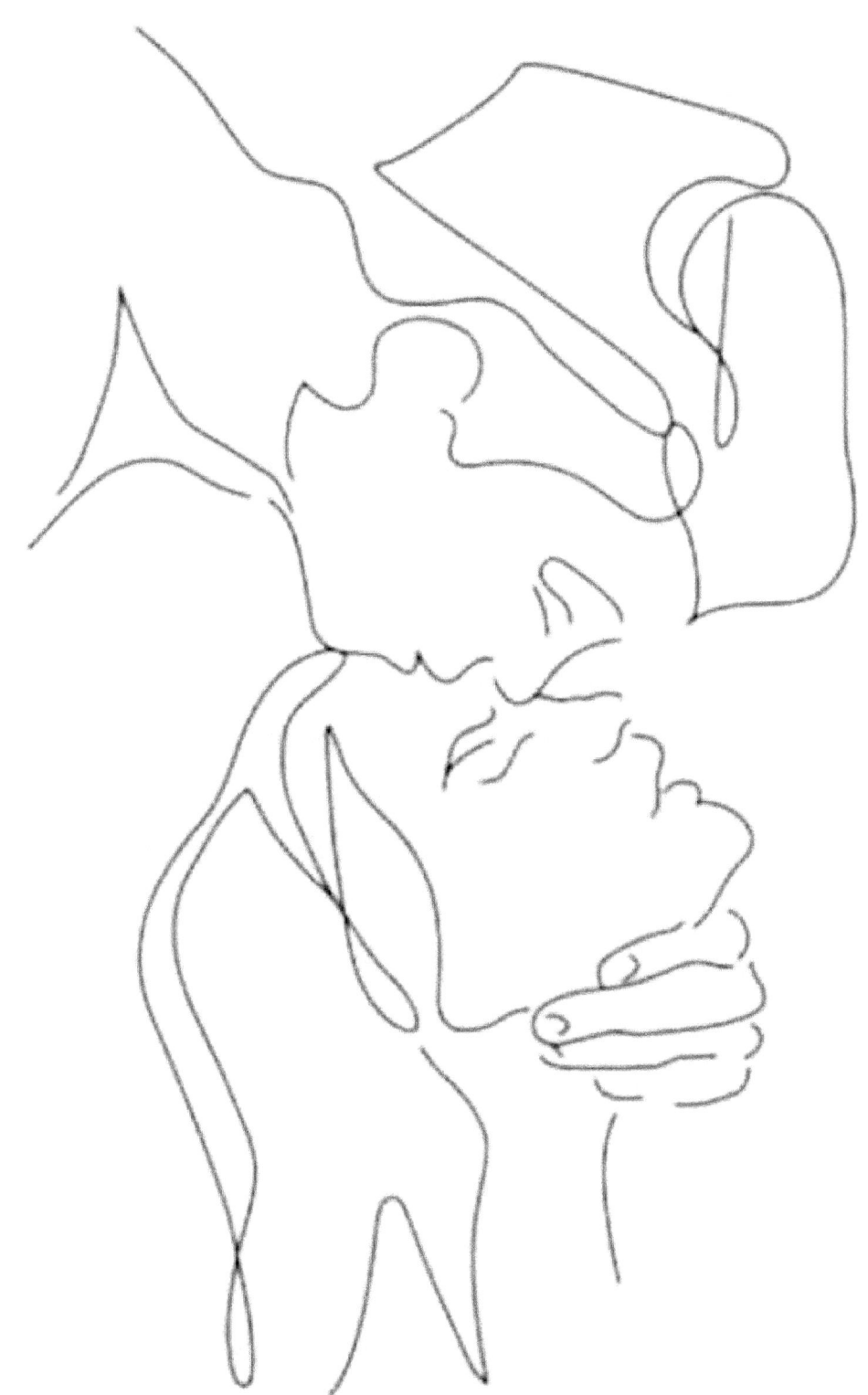

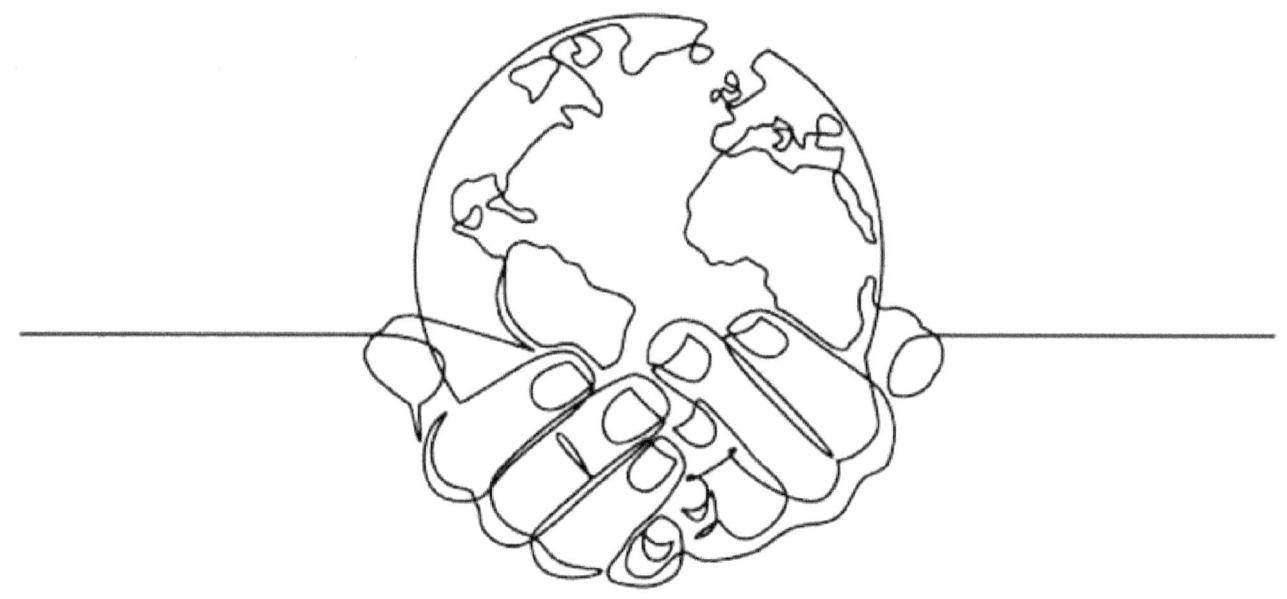

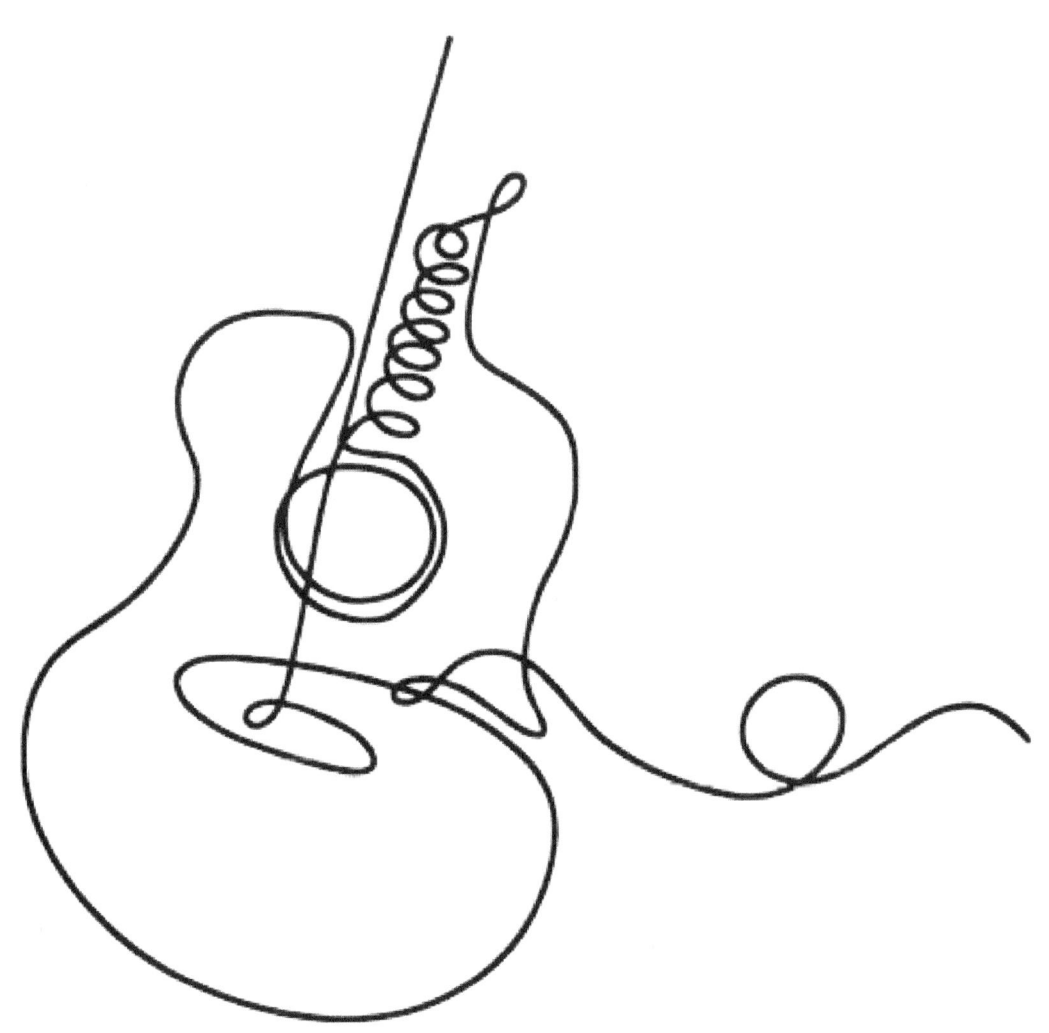

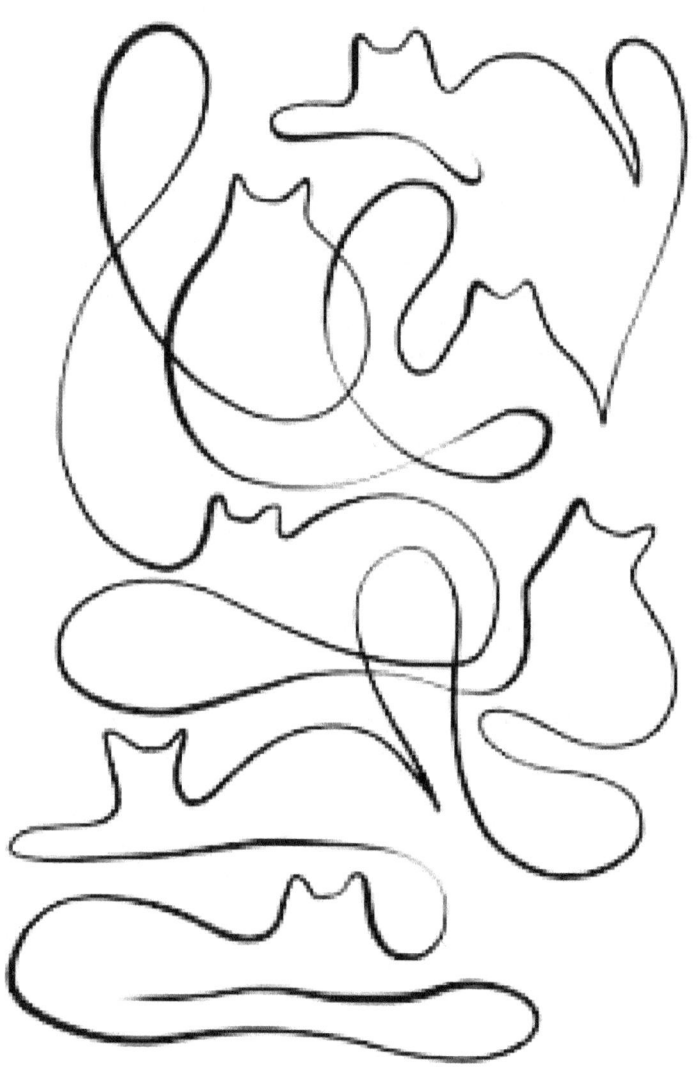

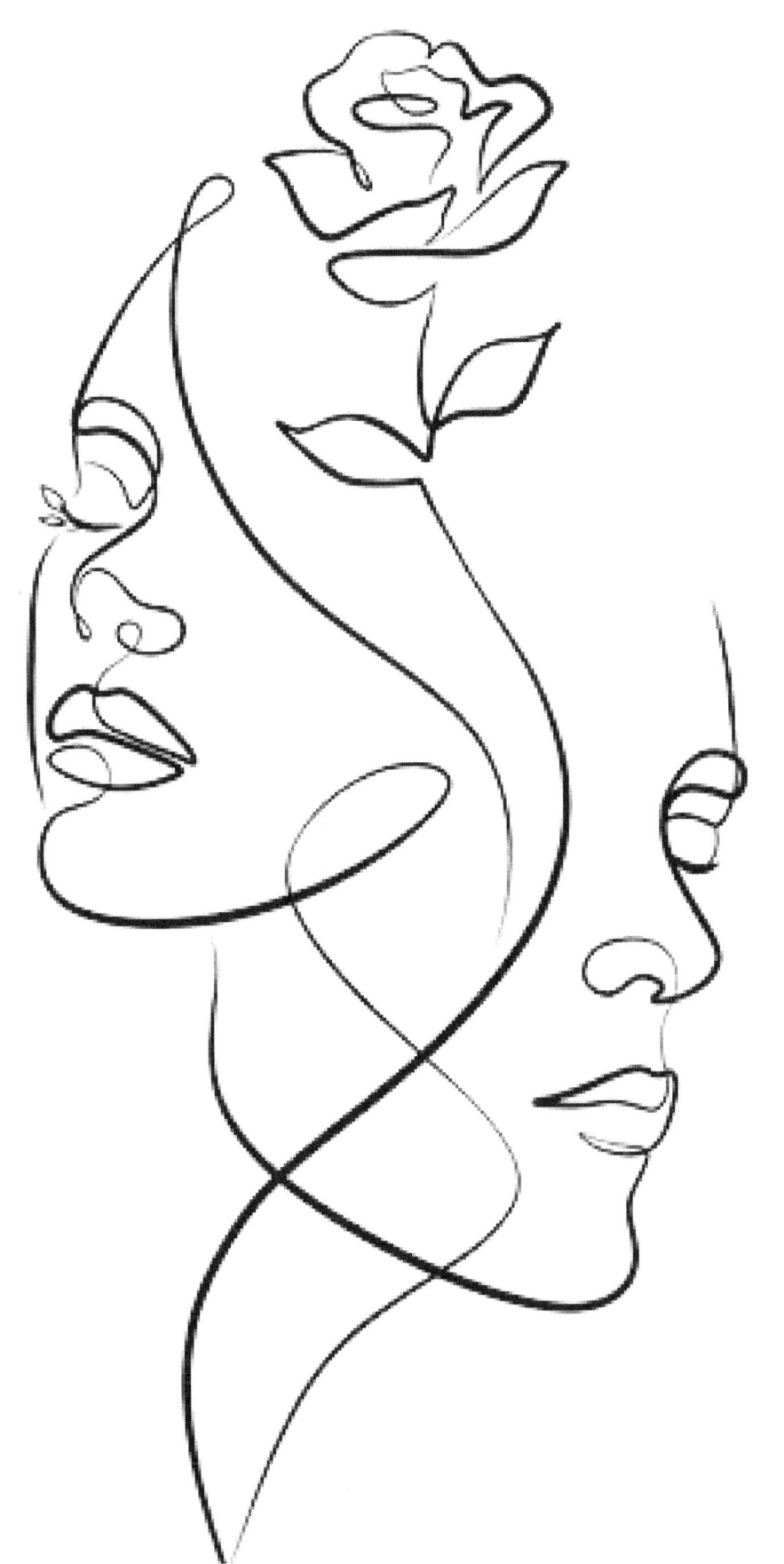

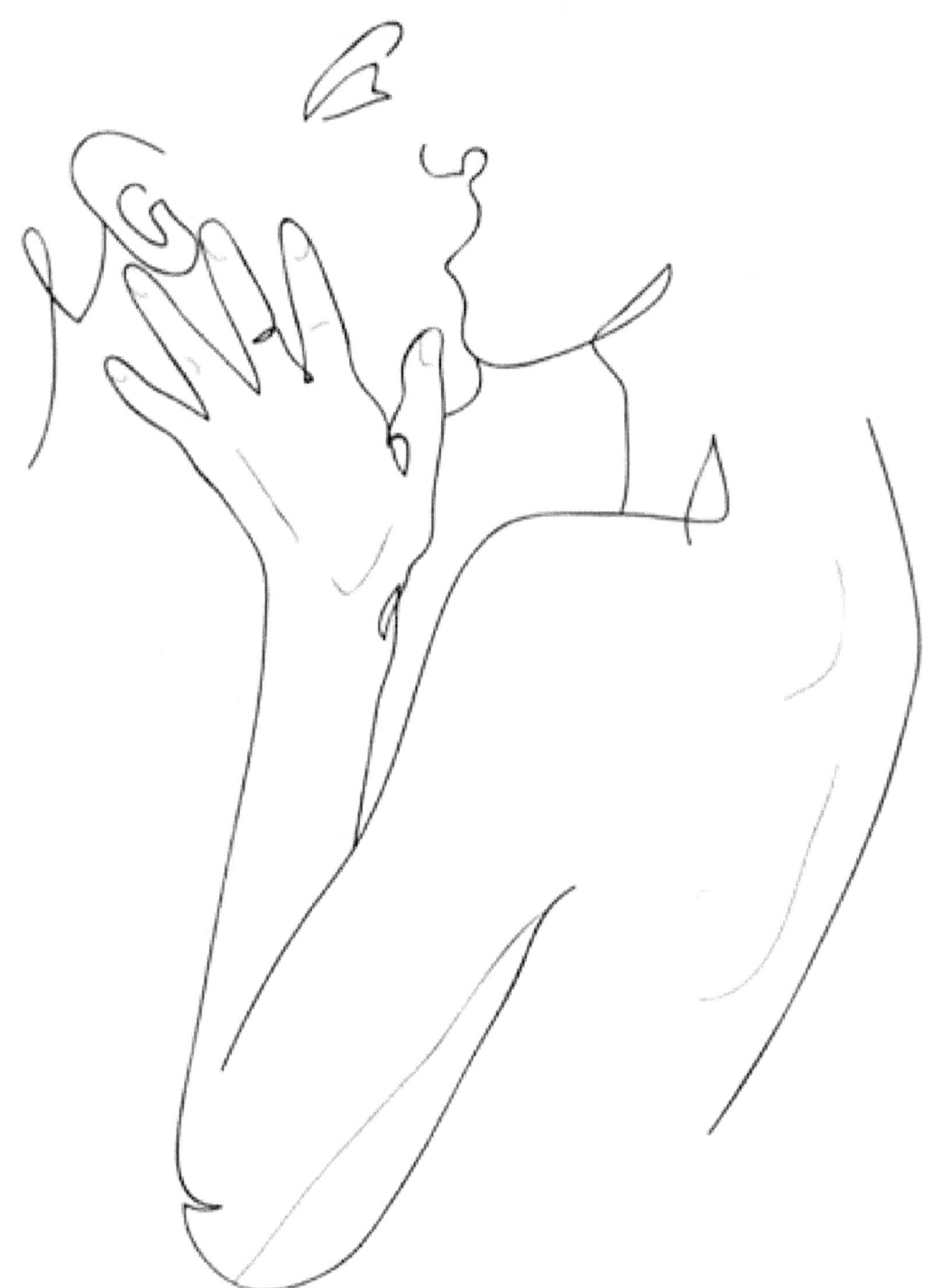

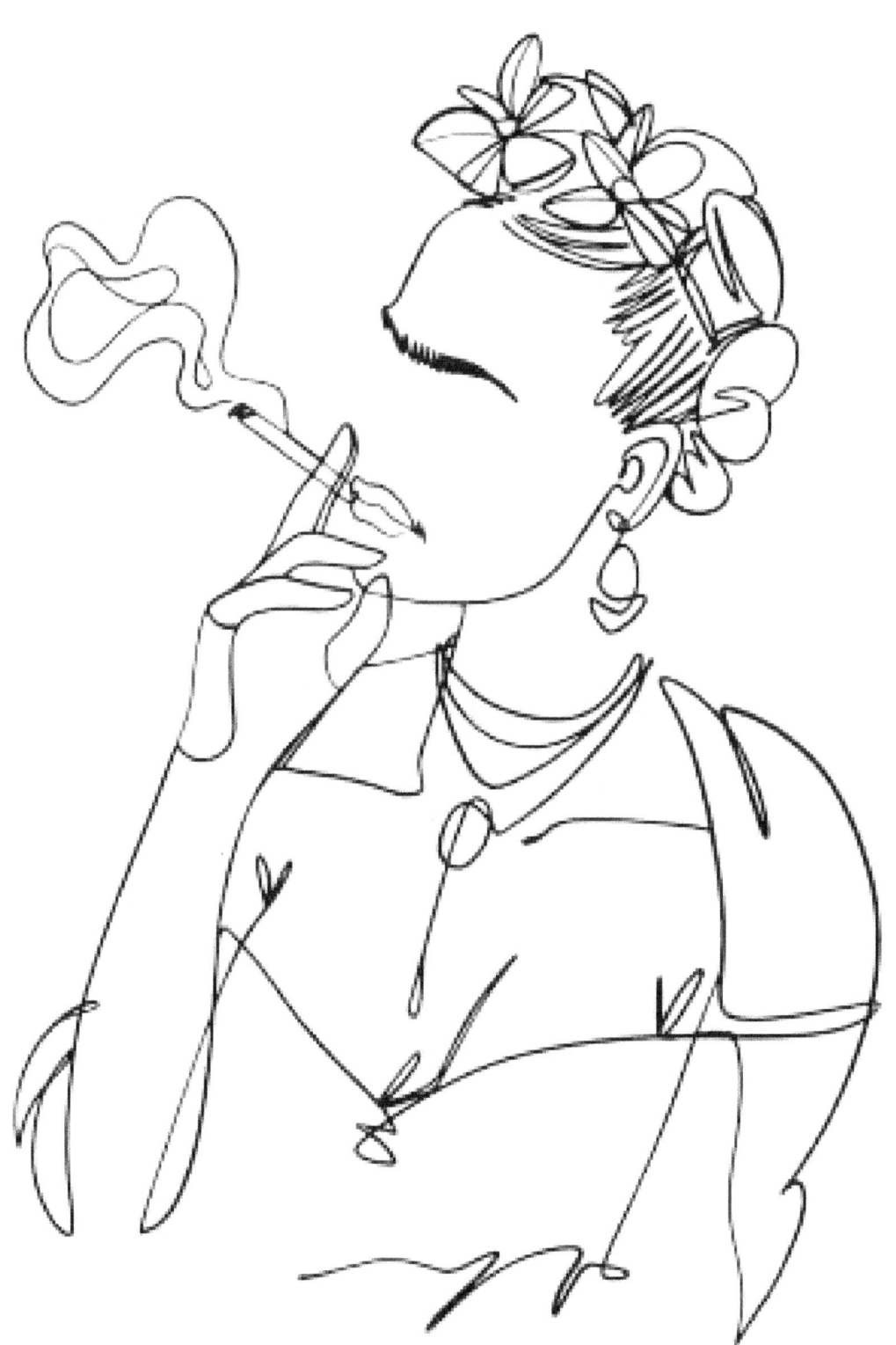

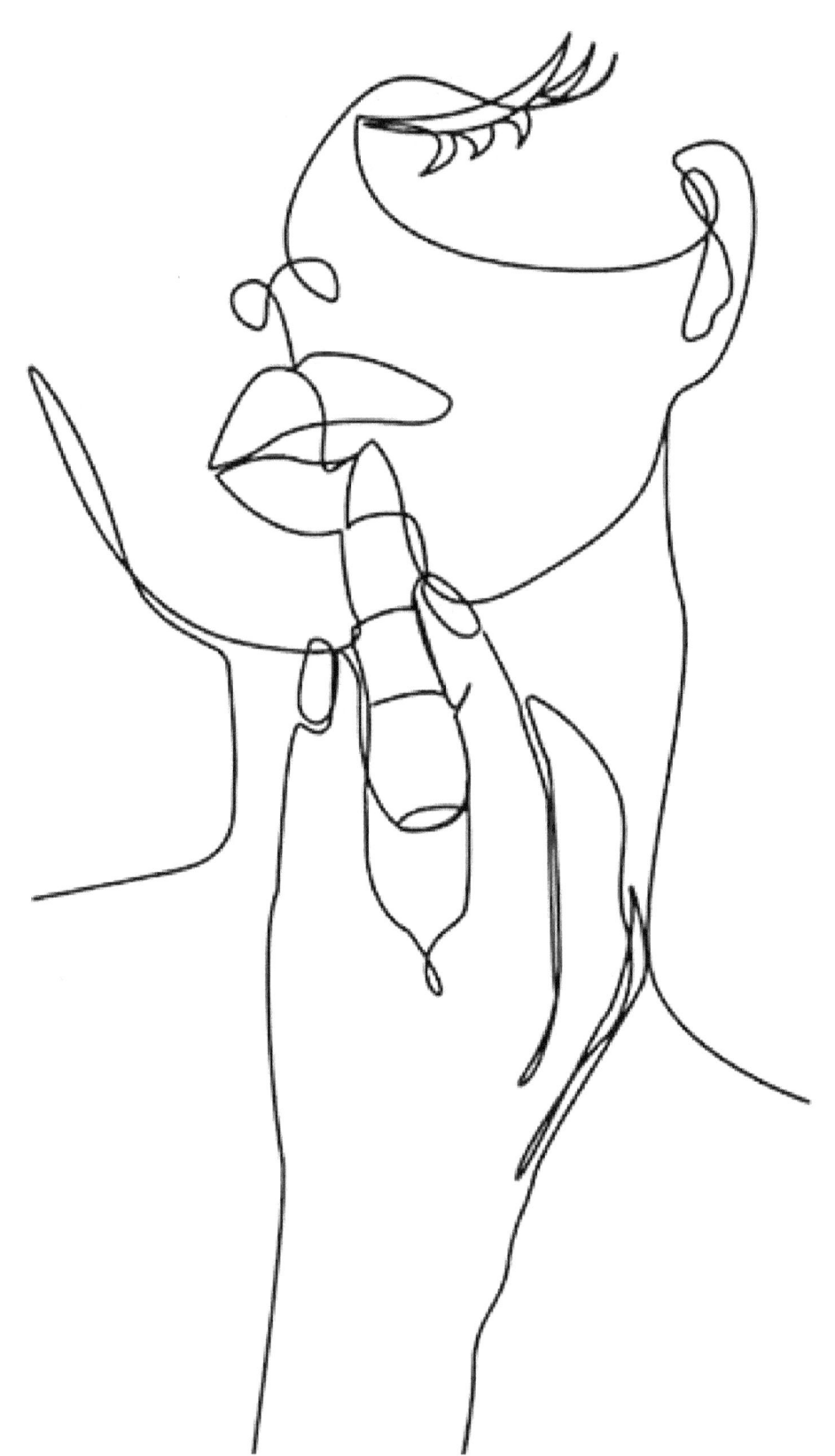

THANKS FOR YOUR PURCHASE
THANK YOU VERY MUCH FOR PURCHASING ONE OF MY BOOKS! I AM GLAD TO KNOW THAT YOU HAVE ENJOYED MY WORK AND I HOPE THAT YOU HAVE FOUND IN IT THE INSPIRATION AND KNOWLEDGE YOU WERE LOOKING FOR.

IF YOU ARE HAPPY WITH YOUR PURCHASE, I WOULD LOVE FOR YOU TO SHARE YOUR OPINION THROUGH A REVIEW. YOUR COMMENTS ARE VERY VALUABLE TO ME AND HELP ME TO CONTINUALLY IMPROVE.

GET A FREE SMALL DESIGN BOOK IN PDF FORMAT.
TO THANK YOU FOR YOUR SUPPORT, I WOULD LIKE TO INVITE YOU TO SCAN THE QR CODE WHERE YOU CAN ACCESS THE FREE DOWNLOAD. I HOPE YOU ENJOY THIS LITTLE GIFT AND CONTINUE TO ENJOY MY POSTS.
THANK YOU VERY MUCH AGAIN FOR YOUR PURCHASE AND YOUR TIME! I WILL BE HAPPY TO RECEIVE YOUR COMMENTS.
SINCERELY.

www.ingramcontent.com/pod-product-compliance
Lightning Source LLC
Chambersburg PA
CBHW062315220526
45479CB00004B/1170